HANGJIA
DAINIXUAN

行家带你选

蜜 蜡

姚江波 / 著

中国林业出版社

图书在版编目(CIP)数据

蜜蜡/姚江波著. -北京:中国林业出版社, 2019.6
(行家带你选)
ISBN 978-7-5038-9970-6

I.①蜜… II.①姚… III.①琥珀-鉴定 IV.① TS933.23

中国版本图书馆CIP数据核字(2019)第044779号

策划编辑　徐小英
责任编辑　徐小英　梁翔云
美术编辑　赵　芳　刘媚娜

出　　版　中国林业出版社(100009 北京西城区刘海胡同7号)
　　　　　http://www.forestry.gov.cn/lycb.html
　　　　　E-mail:forestbook@163.com　电话：(010)83143515
发　　行　中国林业出版社
设计制作　北京捷艺轩彩印制版技术有限公司
印　　刷　北京中科印刷有限公司
版　　次　2019年6月第1版
印　　次　2019年6月第1次
开　　本　185mm×245mm
字　　数　161千字（插图约230幅）
印　　张　9.5
定　　价　65.00元

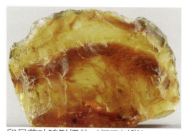

印尼蓝珀随形摆件（柯巴树脂）

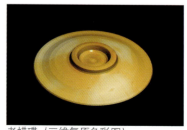

老蜡碟（三维复原色彩图）

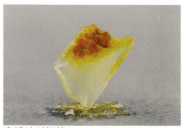

蜜蜡随形摆件

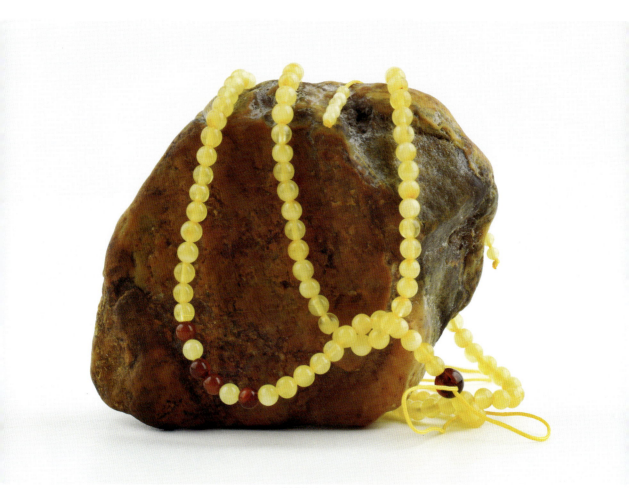

蜜蜡串珠

◎ 前 言

　　蜜蜡是树脂化石，是一种有机宝石，在化学成分上与琥珀没有区别。在国外其实是没有琥珀蜜蜡之分的，但在国内显然蜜蜡形成了一个独立的品类，因其色彩如蜜，光泽似蜡，故而得名。蜜蜡的形成需要很长时间，有的蜜蜡在生成年代上可以达到几千万年到上亿年，民间有"千年琥珀，万年蜜蜡"之说。蜜蜡形成的过程与琥珀十分相似，都是由松柏科植物树脂在空气中硬化，再深埋在地层中石化而来，松柏科植物的树脂在空气中凝固，经过千百万甚至是上亿年的沧海桑田，蜜蜡已经形成了化石，松脂被永远的定格。造化弄人，蜜蜡色彩并非都是"色如蜜"，而是金黄、红色、枣红、橘红色、蓝色、深红色、蓝紫色、米色、紫红色、青色、褐色、米白色、红色略泛褐色、鸡油黄、白色、棕色、黑色、蛋青色、紫色、绿色、咖啡色、浅黄色、土色等都有见，流光溢彩，色彩斑斓。蜜蜡本色是黄色的，因为松脂的色彩是纯正的黄色，但由于埋藏环境的不同，蜜蜡受到矿物侵染的程度也不同。如在含铁的环境当中，自然会变成棕红、铁红、枣红等。总之，环境不同，蜜蜡色彩各异。蜜蜡的产地非常多，中国及世界上很多国家都出产，如俄罗斯、乌克兰、法国、德国、英国、罗马尼亚、意大利、波兰等国家都有见，特别是俄罗斯、乌克兰等国的产量特别大，基本上占到整个世界蜜蜡产量的90%以上，我国则是很少见到，只是偶见。目前，蜜蜡以进口料为主。蜜蜡以其固有的美丽，打动了很多人，使人们趋之若鹜。在我国，很早就有见，汉墓当中就有见，魏晋以降，直至明清，只是数量比较少，体积比较小，大器基本不见，这与古代蜜蜡原材进口不畅有关。当代蜜蜡在数量上则是达到了一个新的高度，市场上蜜蜡制品琳琅满目，数量众多，且在品质上与古代蜜蜡相比优者更优，次者更次，呈现出两极分化的发展趋势。这主要得益于波罗的海沿岸国家优质蜜蜡进入中国的通道比较顺畅，蜜蜡原材达到历史上最为丰富的时期，这为蜜蜡大器、及精品力作的出现打下了基础，当代蜜蜡数量也发展成为历代之最。由上可见，蜜蜡制品自产生之后就以前所未有的速度迅猛发展，在中国历史上产生了无与伦比的造型种类，如手镯、胸针、觿、簪、松鹤山子、葫芦、印章、项链、手串、吊坠、佩饰、狮、虎、臂搁、佛珠、如意、挂件、随形山子、戒指、块状随形、耳环、多宝串、观音、弥

蜜蜡单珠、唐三彩碟组合
(三维复原色彩图)

勒、佛像、貔貅、单珠、筒珠、笔舔、金瓜、瑞兽、婴戏、荷花等,犹如灿烂星河,群星璀璨。当然,并不是所有的造型在历史上都非常流行,包括我们现在也是这样,还有很多的蜜蜡造型没有大规模地流行过,或只是短时间的流行,在历史上"昙花一现",很快就消失了。但也有一部分造型由于功能的需要,依然保留至今,如吊坠、印章、手串、葫芦、手镯等,几乎贯穿了中国古代历史的全过程,成为帝王将相、市井百姓把玩的饰品之一。

中国古代蜜蜡虽然离我们远去,但人们对它的记忆是深刻的,这一点反映在收藏市场之上。在收藏市场上,历代蜜蜡受到了极大的欢迎,各种古代蜜蜡在市场上交易频繁,高古蜜蜡数量少一些,主要以明清及民国当代蜜蜡为主。由于中国古代蜜蜡是人们日常生活当中真正在佩戴和把玩的器物,特别是当代生产量规模巨大,是有机宝石当中的重要品类之一。这样,从客观上讲,收藏到古代及当代蜜蜡精品的可能性比较大。但由于蜜蜡温润异常,为人间灵物,再加之价格较高,以克论价,优者数万,客观上硬度不高,作伪比较方便,技术含量又低,这也注定了各种各样伪的蜜蜡频出,成为市场上的鸡肋,高仿品与低仿品同在,鱼龙混杂,真伪难辨,蜜蜡的鉴定成为一大难题。本书从文物鉴定的角度出发,力求将错综复杂的问题简单化,以色彩、质地、造型、纹饰、厚薄、重量、风格、雕工、打磨等鉴定要素为切入点,具体而细微地指导收藏爱好者由一件蜜蜡的细节去鉴别蜜蜡之真假、评估蜜蜡之价值,力求做到使藏友读后由外行变成内行,真正领悟收藏,从收藏中受益。以上是本书所要坚持的,但一种信念再强烈,也不免会有缺陷,希望不妥之处,大家给予无私的批评和帮助。

姚江波

2019 年 5 月

◎ 目 录

蜜蜡随形摆件

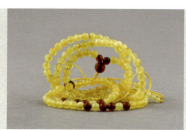

蜜蜡串珠

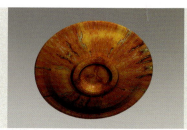

蜜蜡碟（三维复原色彩图）

前 言 /4

第一章　质地鉴定 /1

 第一节　概　述 /1

 一、概　念 /1

 二、老　蜡 /2

 三、新　蜡 /3

 四、非洲老蜜蜡 /4

 五、柯巴树脂 /5

 六、产　地 /8

 七、断　口 /11

 第二节　质地鉴定 /12

 一、硬　度 /12

 二、密　度 /13

 三、折射率 /13

 四、油炸蜜蜡 /14

 五、香　味 /16

 六、染　色 /17

 七、盐　水 /18

 八、针烧法 /19

 九、气　泡 /19

 十、脆　性 /20

 十一、声　音 /20

 十二、牙　咬 /20

 十三、绺　裂 /21

 十四、点　燃 /22

 十五、光　泽 /23

 十六、溶　水 /23

 十七、透明度 /24

 十八、紫外线 /25

 十九、静电性 /25

 二十、手　感 /26

 二十一、纯净程度 /27

 二十二、精致程度 /28

 二十三、刀剐法 /29

 二十四、辨伪方法 /29

 二十五、仪器检测 /30

第二章　蜜蜡鉴定 /32

 第一节　特征鉴定 /32

 一、出土位置 /32

 二、数量特征 /34

 三、完残特征 /35

 四、伴生情况 /37

 第二节　工艺鉴定 /40

 一、穿　孔 /40

 二、打　磨 /42

 三、使用痕迹 /45

 四、镶　嵌 /48

 五、纹　饰 /49

 六、文　字 /53

 七、色　彩 /54

 八、做　工 /58

 九、功　能 /60

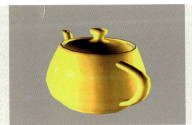
老蜡执壶（三维复原色彩图）

蜜蜡如意

蜜蜡摆件

第三章 造型鉴定 /62
第一节 蜜蜡造型 /62
一、综 述 /62
二、老 蜡 /69
三、浅黄蜜蜡 /71
四、鸡油黄蜜蜡 /74
五、橘黄蜜蜡 /76
第二节 形制鉴定 /79
一、珠 形 /79
二、圆柱形 /82
三、蟠桃形 /84
四、长方形 /85
五、扁圆形 /87
六、鸡心形 /90
七、椭圆形 /91
八、龟 形 /92
九、方 形 /92
十、环 形 /94

十一、橄榄形 /96
十二、高度特征 /97
十三、长 度 /99
十四、宽 度 /102
十五、厚 度 /103
十六、山 子 /106

第四章 识市场 /114
第一节 逛市场 /114
一、国有文物商店 /114
二、大中型古玩市场 /117
三、自发形成的古玩市场 /120
四、大型商场 /122
五、大型展会 /124
六、网上淘宝 /126
七、拍卖行 /128
八、典当行 /130
第二节 评价格 /132

一、市场参考价 /132
二、砍价技巧 /134
第三节 懂保养 /136
一、清 洗 /136
二、修 复 /137
三、防止高温 /137
四、防止磕碰 /137
五、日常维护 /138
六、相对温度 /139
七、相对湿度 /139
第四节 市场趋势 /140
一、价值判断 /140
二、保值与升值 /142

参考文献 /143

蜜蜡随形摆件

第一章　质地鉴定

第一节　概　述

一、概　念

蜜蜡是一种有机宝石，在物理性质和化学成分上与琥珀没有区别。化学成分主要是碳、氢、氧，微量元素有铝、镁、钙、硅等，还含有少量的硫化氢等。因其色彩如蜜，光泽似蜡，故而得名。蜜蜡为非晶质体，贝壳状断口，其本质色彩为黄色。蜜蜡是一种化石，由松柏科植物的树脂石化而形成。蜜蜡形成的时间非常长久，一般的蜜蜡也有几千万年到上亿年，欧洲、中东等地区都发现了1亿年以上的蜜蜡，民间有"千年琥珀，万年蜜蜡"之说。但实际上，形成时间并不是确定蜜蜡的唯一标准，理论上二三百万年以上就可以石化，形成化石。蜜蜡形成的过程与琥珀十分相似，是由松柏科植物的树脂凝固后埋入地下，在地层中深埋，变质而形成。蜜蜡依据不同的分类标准，可分为老蜡、浅黄蜜蜡、鸡油黄蜜蜡、橘红蜜蜡、米色蜜蜡、青色蜜蜡、褐色蜜蜡、米白色蜜蜡、白色蜜蜡、棕色蜜蜡、蛋青色蜜蜡、绿色蜜蜡、土色蜜蜡、咖啡蜜蜡、红棕等诸色蜜蜡，鉴定时应注意分辨。

蜜蜡摆件

蜜蜡串珠

蜜蜡串珠

二、老 蜡

老蜜蜡的概念比较清楚，就是指古董老蜜蜡。我们来看一则实例，"鼻烟壶1件。M2∶4-2，此壶以蜜蜡为原料，红棕色，受沁（紫色外退色），形为扁体长方形，直颈圆口，圈足。表面光滑无花纹。半圆形的盖以翠绿色翡翠制成。壶高8、腹径5.5、口径2.2、底径3.7厘米×1.7厘米"（苏州博物馆，2003）。这就是一件老蜜蜡制品。当然不只是清代有，在更为古老的时期，如秦汉时期就常见蜜蜡制品出现在墓葬当中。所以老蜜蜡可以说基本上具有文物价值，时代久远。老蜡造型丰富，如手链、手串、吊坠、单珠、挂件、随形山子、戒指、耳环、项链等都有见。总之是以古代的造型为主，造型规整，弧度圆润，造型隽永，雕刻凝练，精美绝伦，以小器为主。在色彩上，老蜡色彩由于暴露在空气中时间比较长，表面氧化得比较厉害，通常表面呈现出棕红、枣红、深红等色，而且有一个从黄到红的过程。因为蜜蜡本源的色彩是黄色，当蜜蜡暴露在空气中之后，炎热的天气使得琥珀不断脱水出现风化，自然色彩就会一点点地变化，从淡红色向比较深的红色演变。从产地上看，阿富汗、印度、缅甸、中国西藏的老蜜蜡都是人们搜罗的对象，的确这些地方都出现了一些品质比较高的优质老蜜蜡。不同地区所产的蜜蜡在色彩等诸多特点上有所不同，这主要是由于受到传统的影响所导致。但是蜜蜡的概念还是有很多争议，主要有两种争议，因为一些蜜蜡矿体暴露在地表之后，显然经过长时间的风化，基本上与古代人们曾经使用过的

老蜡珠

老蜡珠

蜜蜡在色彩等诸多特质上很相似，那么用这类蜜蜡原石在当代制作的蜜蜡是否属于老蜡的范畴？目前市场上主要的争议就在这里。实际上本书作者认为，这应该是两个问题，而很多人将其看成一个问题，一定要决出一个雌雄，实际上没有这个必要。因为这应该是老蜡料问题，使用老蜡料制作的产品显然也是老蜡。只不过与文物的概念不同，当代制作的应该是老料新工；而古代墓葬当中出土的器物应该是老料老工。老料新工反映的是当代的制作工艺和老料的珍贵性。而老料老工，反映的是古代的工艺和老料的价值，比当代多的就是它承载着许多历史信息，不仅是化石，而且是历史的化石。二者哪一个更珍贵，更没有可比性，因为墓葬出土的蜜蜡可能承载着很重要的历史信息，但是它的料子或许没有当代使用的老蜜蜡料优良，所以二者虽然都是老蜜蜡，但二者没有可比性。这一点我们在鉴定时应注意分辨。

三、新 蜡

新蜜蜡是相对于老蜜蜡的一个概念，就是指当代开采出来的蜜蜡。用这些蜜蜡制作而成的蜜蜡料显然就属于新蜡的范畴，我们现在市场上出现的蜜蜡产品基本上都是新蜡。其实新蜡的概念并没有太大的意义，因为从辩证的观点来看，时光匆匆，今日的这些新蜡就是将来的老蜡，主要还是应该看其料子的优良程度，及工艺的精绝程度。这一点我们在鉴定时应注意分辨。

蜜蜡随形摆件

蜜蜡如意

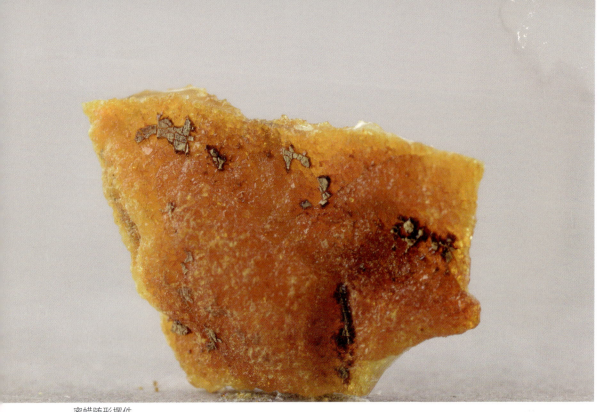

蜜蜡随形摆件

四、非洲老蜜蜡

　　非洲老蜜蜡是一个历史事件，是一个轮回的宿命。事情是这样的，在19世纪，殖民者为了掠夺非洲的财富，有意识地利用工业化的成果，人工合成了数量相当庞大的蜜蜡，有的是塑胶的，也就是假蜜蜡，同非洲进行贸易，甚至换取黄金。而当时的非洲土著人对这些蜜蜡爱不释手，将其作为吉祥物来佩戴。如此大规模的进行欺骗，可见殖民者的卑鄙，为了钱什么事情都会去做。而这种事情在当代肯定也少不了，我们在对外交往中应注意到这些情况。但当时的非洲科技落后，不能检测这些伪品，这些伪器流散于非洲各地，主要集中在摩洛哥等地。时光荏苒，同样的宿命又落在了当代欧美人身上。在百年之后，欧美人士到了非洲一看，这么多珍贵的老蜡，不惜重金，进行购买，根本就没有想到非洲的这些老蜜蜡是假的。因为非洲人没有能力制作出如此高品质的老蜜蜡，非洲人也不知道是假的，只知道值钱，比当时买的时候翻了不知多少倍。但假的真不了，后来终于发现这些从非洲淘回来的是伪器，没有任何收藏价值。于是，非洲老蜜蜡几乎成为了这类假蜜蜡的代名词。我们在鉴定时一定要注意分辨。

五、柯巴树脂

利用柯巴树脂仿造蜜蜡是较为常见的一种方法,要想破解这一作伪的难题,必须先了解什么是柯巴树脂。柯巴树脂和蜜蜡、琥珀很像,它们本质上是一种物质,也是天然树脂凝结形成的,只是形成时间短,石化程度不高,一般情况下只有几百万年时间,所以应该说是琥珀的孩童时代。而我们知道蜜蜡是完全石化的树脂,形成时间一般是几千万年,一些长达上亿年。柯巴树脂由于没有完全石化,所以它的熔点比较低,通常情况下一百多摄氏度就融化了;而我们知道要想烧熔蜜蜡需要接近三百摄氏度的高温。但是由于是蜜蜡的前身,必然和蜜蜡十分相似,而实际上这种柯巴树脂再经过亿万年的岁月,理论上也会从亚石化变成化石,成为蜜蜡。也正是由于这种相似性,促使了作伪者常常使用柯巴树脂冒充蜜蜡。从色彩上看,柯巴树脂的色彩比较简单,色彩没有蜜蜡丰富,多是以黄色为基调,而且色彩黯淡者多,光亮程度不够,所以柯巴树脂在制作时往往染色的情况比较多,将色彩变得鲜亮。另外,燃之有很大的松香味,这一点比较迷惑人,其实真正的蜜蜡由于石化比较好,燃之松香味只是淡淡的,鉴定时应注意分辨。从产地上看,柯巴树脂的产地比较多,南美洲、南亚、大洋洲、哥伦比亚、印度、巴西、布尔内岛、东非、菲律宾、巴布亚新几内亚、新西兰、印度尼西亚等都有见,特别是印度尼西亚和哥伦比亚的柯巴树脂在我国发现较多。另外,中国也有许多柯巴树脂,价格非常便宜,常常被作伪者利用制作蜜蜡。下面我们来看一下柯巴树脂的一些特点。

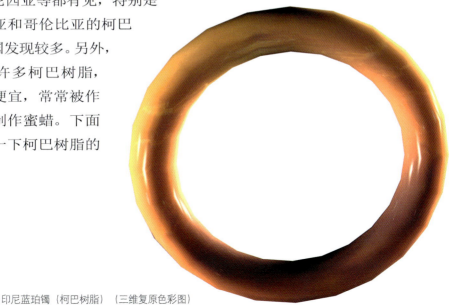

印尼蓝珀镯(柯巴树脂)(三维复原色彩图)

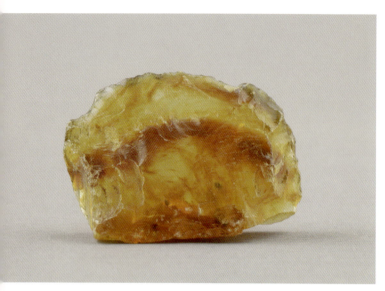

印尼蓝珀随形摆件（柯巴树脂）

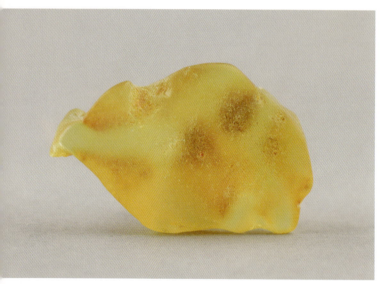

南美洲琥珀随形摆件（柯巴树脂）

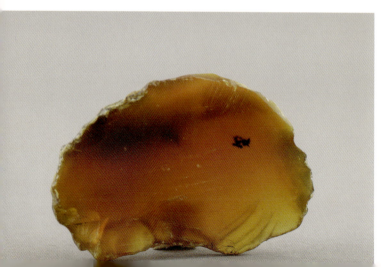

印尼蓝珀随形摆件（柯巴树脂）

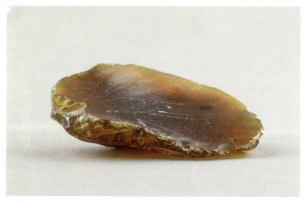
印尼蓝珀随形摆件（柯巴树脂）

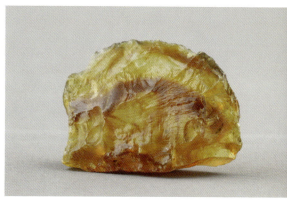
印尼蓝珀随形摆件（柯巴树脂）

从温度上看，柯巴树脂在特征上比较明确，由于其没有完全石化，所以熔点比较低，拿火一烧，一百多摄氏度就会变软，蜜蜡需要更高的温度，加一半的温度，三百摄氏度差不多才能将蜜蜡烧化。如果放在沸腾的水里煮，柯巴树脂也会不同程度地变软，而真正的蜜蜡不会。我们在鉴定时应注意分辨。

从变色上看，柯巴树脂在色彩上褪色比较快，当然蜜蜡的色彩也会变，但变化的速度比较慢，而且色彩变化是向浅淡的方向变化，而不会变成蜜蜡的色彩，老蜡的色彩就更不要想了。我们在鉴定时应注意分辨。

从脆性上看，柯巴树脂由于质地比较软，比蜜蜡还要软，所以用指尖就可以划出痕迹，非常脆，容易碎，容易有裂纹，如果太阳暴晒几天，表面就会出现裂纹，而蜜蜡则不会这么快。

从酒精法上看，柯巴树脂对于酒精特别敏感，如果我们在实验室内用滴管滴一滴酒精在柯巴树脂上，反应很强烈，因为它的表面没有完全石化，基本上就是酒精同松脂的接触。被溶解的表面形成黏稠状的物质；而蜜蜡由于是化石，所以短时间反应不大。

印尼蓝珀随形摆件（柯巴树脂）

哥伦比亚琥珀随形摆件（柯巴树脂）

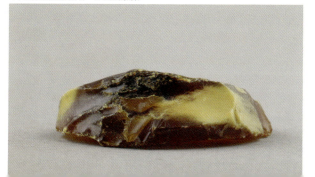

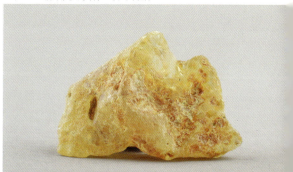

六、产 地

蜜蜡的产地较之琥珀要少得多,我国抚顺主要产的是矿珀,虽然蜜蜡本质也属于琥珀的一种,但是在抚顺矿珀、还有河南西峡的药珀当中很难见到蜜蜡,所以目前市场上的蜜蜡基本上以进口料为主,以波罗的海沿岸国家为主,如俄罗斯、乌克兰、罗马尼亚、意大利、波兰等国,这些蜜蜡在数量上相对较多,色彩主要以黄色为主,色如蜜,与其名称最为贴切,受到人们喜爱。但是有些蜜蜡有的形成年代比较短,只有五六百万年的时间。当然这一地区几千万年乃至上亿年的蜜蜡都有见。在形成年代上普遍比较久远的是中东地区,如阿富汗、伊朗等地的蜜蜡在形成时间上普遍达到五六千万年,甚至有的上亿年。包括缅甸、巴基斯坦的蜜蜡在形成时间上也都是比较长,千万至上亿年的时间。目前我国市面上所见到的蜜蜡主要产地是美洲多米尼加、波罗的海沿岸国家及缅甸、巴基斯坦、阿富汗等,主要是由这些国家的商人从本国搜罗、开采而来,他们有的还在北京的一些古玩城内有摊位,平日里拉着大箱子到处参加展会,但我们不要被外国人外表所迷惑,以为只要是外国人所拿的蜜蜡就是真的,还是要经过科学的检测,鉴定时应注意分辨。

蜜蜡随形摆件

蜜蜡随形摆件

第一节 概述

老蜡珠

蜜蜡随形摆件

蜜蜡执壶（三维复原色彩图）

老蜡珠

蜜蜡随形摆件

蜜蜡串珠

七、断 口

蜜蜡的断口特征比较明显，就是在应力的作用下蜜蜡产生破裂面，为贝壳状断口。断口也是决定蜜蜡价值的重要依据，通常情况下不同宝石的断口特征各异，但大致可以分为齿牙状、起伏不平状、还有就是贝壳状的断口。如果是齿牙状和起伏不平状的断口，就说明它不是琥珀，当然也就不是蜜蜡了，这一点我们在鉴定时应注意分辨。

蜜蜡摆件

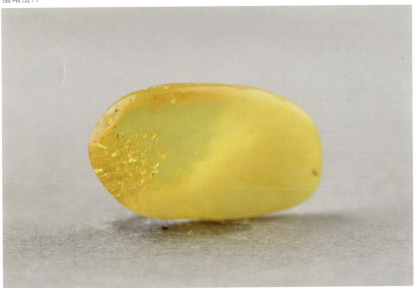

蜜蜡摆件

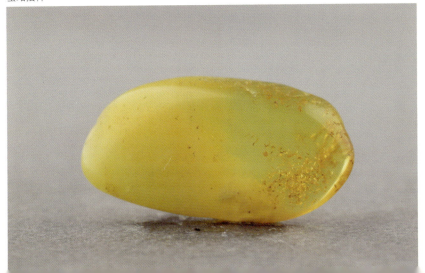

第二节　质地鉴定

一、硬　度

蜜蜡的硬度反映了其抵抗外来机械作用的能力，如雕刻、打磨等，是自身固有的特征。蜜蜡的硬度通常在 2～3 之间，可见蜜蜡的硬度不高，属于比较软的石头。硬度是蜜蜡鉴定的重要标准。蜜蜡的硬度和琥珀相当，因为琥珀和蜜蜡本身就是一种材质，只是将琥珀中的一种色如蜜、光如蜡者单独挑出称之为蜜蜡，所以在物理性质上基本是一样的。对于蜜蜡硬度的测定是鉴定中的一个重要环节，不可以省略。

蜜蜡随形摆件

蜜蜡随形摆件

蜜蜡随形摆件

蜜蜡碟（三维复原色彩图）

二、密 度

蜜蜡在致密程度上不是很好，这与其松柏科植物树脂的固有特征关系密切。蜜蜡的密度为：1.1～1.16克/立方厘米，基本上同琥珀是一样的，因为其本身就是琥珀的一个品种。由此可见，蜜蜡在质地上相当松软，这样的致密程度使蜜蜡一方面很容易碎裂，出现裂纹；不能太阳暴晒，不然会开裂。从轻重上看，蜜蜡的密度反映其内部结构疏松，则必然会造成其很轻的一个状态，鉴定时应注意分辨。

三、折射率

光通过空气的传播速度与光在蜜蜡中的传播速度之比为1.53～1.543，这是一个近乎固定的数值，也是蜜蜡鉴定中重要的参数。我们在鉴定时与其进行对比显然就可以洞穿真伪。

蜜蜡随形摆件

蜜蜡串珠

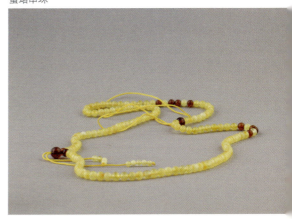

四、油炸蜜蜡

这是民间的一种优化方法,也就是蜜蜡的热处理,简单地说就是将蜜蜡放入油锅中炸一炸,目的是将蜜蜡较为疏松结构中的气泡炸得爆裂,最大限度地消除云雾状遮隐,使蜜蜡变得更加通透。这类蜜蜡在市场上很常见。但是这类蜜蜡其内部结构在其气泡爆裂后,会产生爆炸的冲击波,如同太阳光芒般向外衍射,我们在鉴定时应注意观察。经过热处理后的蜜蜡增加了通透性,颜色外观等都会有所改变,但这情况不属于伪造蜜蜡,只是对蜜蜡的一种热处理,矿物学上称之为优化。

仿老蜡珠

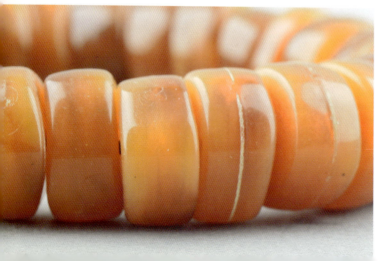

仿蜜蜡算珠手串

仿蜜蜡手串

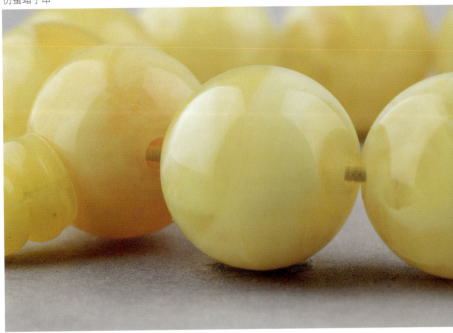

仿蜜蜡筒珠

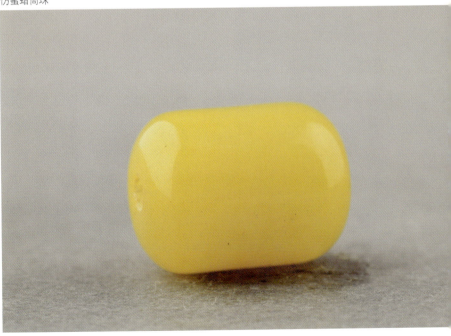

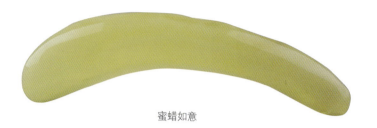

蜜蜡如意

五、香 味

蜜蜡通常情况下具有香味,因为它是松柏科植物的树脂形成的,所以是一种淡淡的松香味。蜜蜡的品质越高,香味越容易闻到。不过有的蜜蜡自然状态下很难闻到香味,经过揉搓后就很容易可以闻到,放到鼻子跟前能够闻到明显的芳香。再者原石比成品更容易闻到芳香味道,这一点我们在鉴定时应注意分辨。

蜜蜡随形摆件

蜜蜡随形摆件

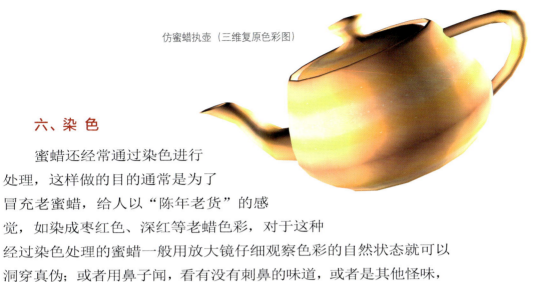

仿蜜蜡执壶（三维复原色彩图）

六、染 色

蜜蜡还经常通过染色进行处理，这样做的目的通常是为了冒充老蜜蜡，给人以"陈年老货"的感觉，如染成枣红色、深红等老蜡色彩，对于这种经过染色处理的蜜蜡一般用放大镜仔细观察色彩的自然状态就可以洞穿真伪；或者用鼻子闻，看有没有刺鼻的味道，或者是其他怪味，也就是化学试剂的味道。

仿蜜蜡算珠手串

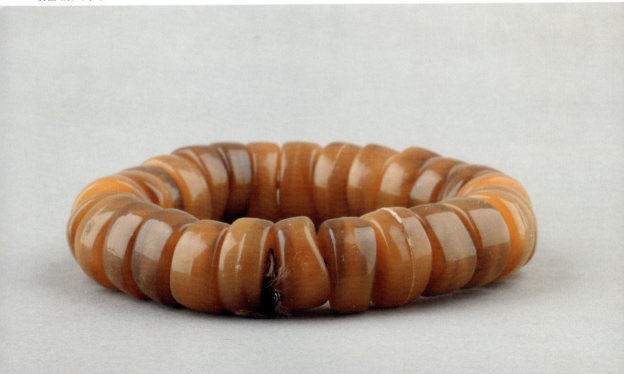

七、盐 水

蜜蜡由于比较轻，在盐水中可浮起，而在清水中则会沉下去，通常 250 毫升的水加上 9 满勺的盐蜜蜡便可以浮起，普通塑料一类就会沉下去。但这一方法看似简单，实际上很难掌握，首先是盐水的比例不好掌握，容易形成误导。如有时盐水的浓度太大，塑料也浮起来了；再者是只有普通塑料和玻璃等传统的作伪材料会沉下去，而新型的轻质塑料等作伪材料同样会浮起来。所以，这种方法只是鉴定方法之一，只是鉴定蜜蜡制品的一种参考，真正鉴定蜜蜡，还是需要多策并举。

蜜蜡随形摆件

蜜蜡随形摆件

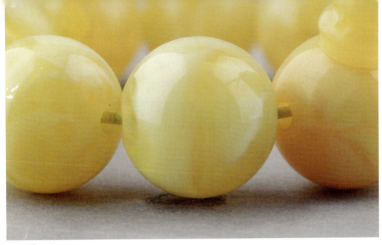

仿蜜蜡手串

八、针烧法

在实验室内将普通的钢针烧红，针刺蜜蜡，真正的蜜蜡会有松香的味道，非常舒服。而如果是柯巴树脂，虽然也有松香味，但针刺部位立刻会被熔化掉，而且会粘住针头，拉着长条的丝线状粘物。而如果是塑料类的材料，那反应就更大了，立刻会闻到刺鼻的臭味，使人不能忍受，真伪立刻被洞穿。

九、气 泡

对于气泡的观察使我们可以轻易识破压制类的蜜蜡。经过压制的蜜蜡内部结构被挤压变形，通常为圆形的气泡多被压成扁圆形，气泡多是沿着一个方向被拉长，有着明显的流动性构造。目前市场上很常见这类蜜蜡，而气泡显然是我们鉴定时应重点注意的问题。

印尼蓝珀碗（柯巴树脂）（三维复原色彩图）　　仿蜜蜡筒珠

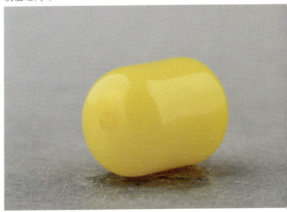

蜜蜡随形摆件

蜜蜡随形摆件

十、脆 性

脆性是物体在受到外界撞击后的基本反应。蜜蜡虽然硬度低，但是密度也小，结构特别疏松，受到外力后反应很强烈，因此蜜蜡非常之脆，掉到地上马上就会碎掉。所以在购买和观察蜜蜡之时应轻拿轻放，避免使蜜蜡受到伤害。

十一、声 音

蜜蜡是一种有机宝石，蜜蜡之间相互揉搓的声音比较沉闷。如果拿蜜蜡手串放在手中轻柔，声音是"咯咯"的（图39），比较沉闷，而不像有机玻璃，或者是聚苯乙烯等塑料制品那样发出清脆响亮的声音，我们在鉴定时应注意分辨。

十二、牙 咬

牙咬咀嚼也是一种辨别蜜蜡真伪的方法，这是因为蜜蜡的硬度比较低，所以可以咀嚼，真品蜜蜡牙咬咀嚼没有沙粒感，这是因为真品蜜蜡已经石化，而且香味不是很大；而柯巴树脂等因为还没有完全石化会发出浓烈的香味，牙还会发黏。当然，塑料和玻璃材料仿造的蜜蜡是咬不动的了。但是这一方法，很多人认为不卫生，很少使用，多是早年在中药店铺内凭经验鉴定的师傅们经常使用。

蜜蜡随形摆件

蜜蜡摆件

十三、绺 裂

蜜蜡有绺裂的情况常见，这与蜜蜡硬度较低，质地较软的固有特征有关。热胀冷缩、太阳暴晒等原因都会导致蜜蜡出现绺裂。在现实中碰到的情况主要有两种：一是原石绺裂，这种比较常见就是原石开裂，当然有的绺裂不是太严重，但是建议慎重，因为随着时间的推移，热胀冷缩的影响会加重其绺裂的程度；二是雕件绺裂，雕件有绺裂的情况通常极为轻微，甚至不容易发现，但这的确不容忽视，因为这些绺裂会越来越严重，直至无法控制。由此可见，绺裂显然会对蜜蜡价值造成决定性的影响。总之，蜜蜡在绺裂上的表现和琥珀很相似，只是蜜蜡在选料时比较讲究，所以显得绺裂比琥珀好一些。

蜜蜡随形摆件　　　　　　　　　　　蜜蜡随形摆件

十四、点 燃

这种方法十分原始,也称之为燃烧法、火烧法、点燃法,就是将蜜蜡用打火机真正点燃。一般点燃后无论真伪都是冒黑烟,但是真正的蜜蜡在刚熄灭时是冒白烟,这与其松柏科植物的树脂本质有关,而且有松香味道;而伪的蜜蜡整个是冒黑烟,气味很浓,有刺鼻的感觉。这一点我们在鉴定时应注意分辨。

蜜蜡随形摆件

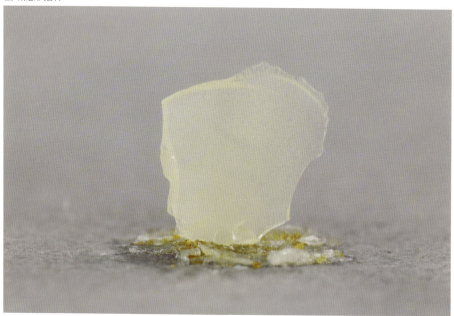

蜜蜡随形摆件

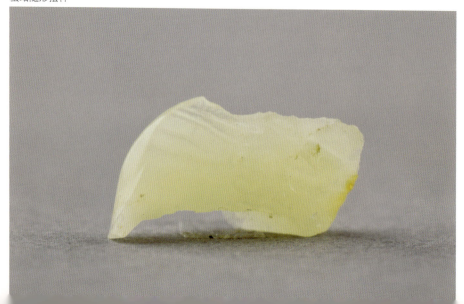

十五、光　泽

光泽是物体表面反射光的能力。而蜜蜡的这种反射能力比较强，但具有一定的复杂性。因为不同色彩的蜜蜡表面对于光线的反射能力也不同，如金黄色的蜜蜡光泽感比较强，在太阳光的照射下鲜亮，熠熠生辉；而红棕色的蜜蜡在光泽上则表现出黯淡、润泽、非常柔和的感觉。我们在鉴定时应注意到色彩对于光泽的影响。不过无论是怎样色彩的蜜蜡，光泽都比较好，多数通体闪烁着非金属的淡雅光泽，同时兼备蜡状光泽，可谓是美不胜收，精美绝伦。

十六、溶　水

溶水是鉴定蜜蜡的重要方法，将蜜蜡放在烧开的水中，如果是柯巴树脂则很容易变软，有的软塑料制品可能就融化了，而真品蜜蜡则不会融化，不会变软，因为是化石质地。如果是染色，也会显现原形。但一般情况下不要使用这种方法。因为蜜蜡的结构是否会起微小的变化，目前研究资料还不是很充分，因此对于鉴定而言，有的时候不是所有的方法都可以适用的，只有对于一些不要的蜜蜡制品，才可以进行破坏性的试验。

蜜蜡随形摆件

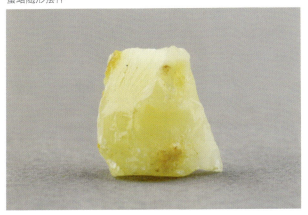

仿鸡油黄筒珠

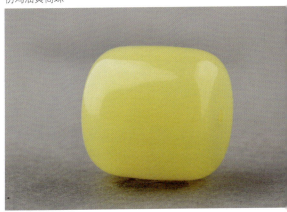

十七、透明度

透明度是蜜蜡透过可见光的程度。蜜蜡透过光的能力本身比较强，但由于蜜蜡在埋藏环境当中容易受到污染，沁染上了各种色彩，以至于使自己变成了某种色彩，如鸡油黄、枣红、棕红等，所以在透明度上也造成了不同色彩的蜜蜡透光程度不同。完全透明的蜜蜡有见，但是很少，以不透或者微透明两种情况为多见。目前民间的说法是透明的为琥珀，不透的为蜜蜡，这完全是狭义上的概念，显然蜜蜡也是比较复杂的，只是说透明的情况经常见到而已，实际上在一件蜜蜡制品之上有一部分是微透的，局部不透的情况也有见，但数量很少。另外，蜜蜡在透明度上也会受到雕件厚度的影响，如厚度越大，透明度越低等。这些因素我们在鉴定时应引起充分注意。

蜜蜡随形摆件

蜜蜡随形摆件

蜜蜡随形摆件

老蜡珠

蜜蜡随形摆件

十八、紫外线

　　紫外线照射的方法在蜜蜡检测当中经常使用，设备也不用专门找，就用验钞机就可以，在紫外线光的照射下蜜蜡表面会有绿色、蓝色、白色等的荧光，较为明显，基本特征是随着通透性的增强荧光会越来越明显，反之则减弱，这一点我们在鉴定时应注意分辨。

十九、静电性

　　静电特性是蜜蜡鉴定中常见的一种方法。就是利用蜜蜡和绝缘材料进行摩擦产生静电效应。一般情况下，和我们所穿的衣服使劲进行摩擦就可以，这种短暂产生的静电电压瞬间可以吸附起纸片，而塑料和玻璃制品，显然不能够产生静电效应，这样立刻就可以使伪器现出原形。再者，蜜蜡的静电效应对人体健康也是非常有益的，比如说人体皮肤的局部可以在这种生活电流的作用下散热较快，在夏季保持皮肤干爽，愉悦心情，十分美妙。

蜜蜡摆件

蜜蜡随形摆件

二十、手 感

　　手感即用手触摸蜜蜡的感觉。作为一种鉴定方法，它不是唯心的，也是一种科学的鉴定方法，而且是最高境界的鉴定方法之一。收藏者在训练这种鉴定方法时需要具备一定的先决条件，就是所触及的蜜蜡必须是真品，而不是伪器。如果是伪器则刚好适得其反，将伪的鉴定要点铭记心中，为以后的鉴定失误埋下了伏笔。谈起蜜蜡触摸的感觉，可能是仁者见仁，智者见智，每个人都有一些感受。但共性的特征显然是细腻、光滑、温润，特别是有机宝石给人们带来特有的暖感，是其他如塑料、玻璃等作伪材料所不具备的。就是冬日里把蜜蜡放在嘴边也是暖的且比较轻，而不像玻璃放在嘴唇边的第一感觉是冰凉的，在鉴定时我们应注意多体会。

蜜蜡随形摆件

蜜蜡随形摆件

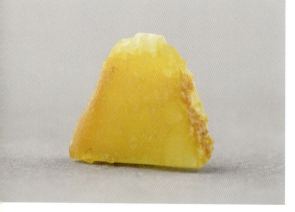

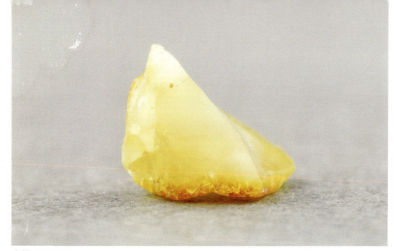

蜜蜡随形摆件

二十一、纯净程度

蜜蜡在纯净程度上比琥珀普遍要好，但杂质显然是不可避免的。没有杂质的蜜蜡理论上是不存在的，只是杂质在轻微程度上有差别，视觉观察不到的即是纯净，如果能够观察到，但非常稀少，杂质有非常小的，这样的情况我们称之为轻微杂质；杂质很明显，而且分布很广的情况是严重杂质。对于蜜蜡而言杂质的多少决定其优劣程度。杂质越少，价值越高；反之，杂质越多就越普通。实际上观测不到杂质的蜜蜡很少见，完全没有杂质的蜜蜡多是收藏级的蜜蜡，分外美丽。对于制作成功的成品来讲，如戒面、吊坠显然在制作时已经最大限度地避免了体内的杂质，所以价值并不是特别高，对于纯正程度最有价值的显然是指蜜蜡原石，鉴定时应注意分辨。

蜜蜡串珠

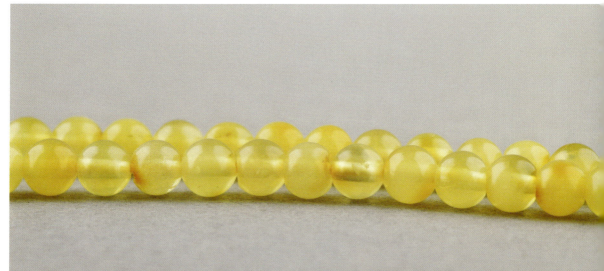

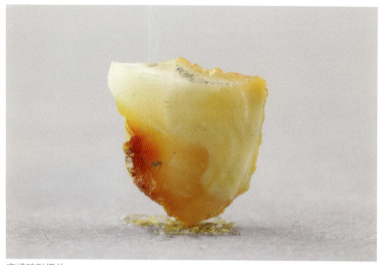

蜜蜡随形摆件

二十二、精致程度

蜜蜡在精致程度上特征比较明确，无论古代还是当代在精致程度上都是比较好，特别是料子比较好的蜜蜡更是这样，人们得到一块料极为不易，因为多数蜜蜡是进口的，可以说是经过千山万水才来到中国，成本很高，以克论价，所以工匠们也都是倍加珍惜。而这种倍加珍惜的思想化作精益求精的独具匠心，在蜜蜡之上明显地体现了出来。古往今来，蜜蜡是以精致为主，普通和粗糙者有见，但数量很少，几乎为偶见，这一点我们在鉴定时要注意分辨。

蜜蜡串珠

二十三、刀剐法

用刀剐法来对蜜蜡进行检测,过程非常简单,就是用刀剐,蜜蜡是呈粉末状的,如果剐到塑料则是一卷一卷的,而如果是玻璃等则剐不动。鉴定时应注意体会。

二十四、辨伪方法

蜜蜡的辨伪方法主要包括三类,一类是对古代蜜蜡文物性质的辨伪,也就是老蜜蜡的辨伪;第二类是对老蜡新工的制品辨识;第三类是对新蜜蜡的质地辨伪。其实三类辨伪方法虽然在细节上不同,但其实方法论就是一种,是人们用它来达到蜜蜡的辨伪目的、手段和方法的总和,因此辨伪方法并不具体。但它只能用于指导我们的行为,以及对于古蜜蜡辨伪的一系列思维和实践活动,并为此而采取的各种具体的方法。由上可见,在鉴定时我们要注意到辨伪方法在宏观和微观上的区别。另外,还要注意到对于蜜蜡的鉴定和辨伪,不是一种方法可以解决的,而是多种方法并用。

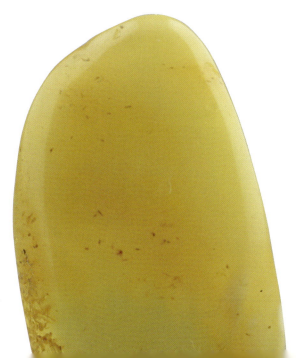

蜜蜡摆件

二十五、仪器检测

在蜜蜡的辨伪当中,科学检测显然已经成为一种风尚,许多蜜蜡制品本身就带有国检证书。但是证书并不代表一切,证书只能检测成分,不能辨别是否为老蜜蜡;是明代的还是清代的,都不能辨别;同时也不能辨明它的优劣;当然也不能辨别再造蜜蜡,就是将蜜蜡打成粉,之后再将其黏合压制成型。这样的蜜蜡欺骗性很高,因为检测都是蜜蜡的成分,可以出具检测证书,但是这类蜜蜡确实是再造的,而且环保的科学性未被认证,大量的黏合剂是否对人体有害,是个未知数。试想,如果买了这样蜜蜡制品,是心情愉悦,还是心情很糟糕呢。所以,仪器检测的优点是需要肯定的,但它只是我们鉴定蜜蜡的第一步,而且是必须要进行的第一步,但不是全部。蜜蜡制品的鉴定需要综合诸多鉴定要点才能确定。

不规则仿蜜蜡珠

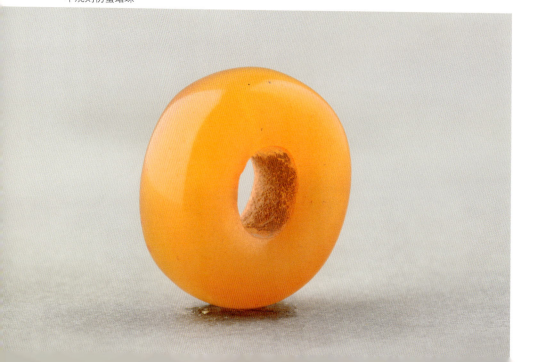

仿蜜蜡筒珠手串

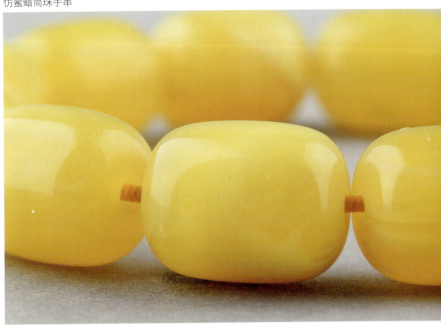

仿鸡油黄筒珠

第二章　蜜蜡鉴定

第一节　特征鉴定

一、出土位置

出土位置特征主要涉及中国古代蜜蜡，不涉及当代蜜蜡。中国古代蜜蜡数量非常少，以墓葬发掘为主，遗址当中很少见到，其中原因主要是蜜蜡原料难得，在古代由于交通等因素不变，更为难得，所以蜜蜡在中国古代是非常珍贵的材料，人们对于蜜蜡非常珍视，多是生前佩戴，死后随葬。墓葬内放置位置多是显要部位，佩戴的位置多如生前，如项链多出土在墓主人胸前，也就是珠子散落的地方。总之，多是出土于棺椁内部，这足以见得墓主人对其的珍视。

蜜蜡随形摆件

蜜蜡随形摆件

从时代上看，商周秦汉时期蜜蜡在出土位置上特征不是很明显，主要原因是出土数量非常少，无法得出一个像样的规律，不过从当时琥珀制品有见于墓葬当中这一点来看，蜜蜡应该也会有见，出土位置应在显著位置。六朝隋唐辽金时期蜜蜡有见，随葬位置基本上与生前无异，但真正发掘出土的亦很少见。宋元明清时期蜜蜡已经成为人们熟知的珠宝，由于物以稀为贵，身份自高远，各种各样的蜜蜡制品出现了，特别是明清时期常见。出土位置多样化，这主要是由于镶嵌类的产品出现，所以蜜蜡逐渐摆脱了佩戴于胸前部位，以项链随葬的位置。但即使镶嵌也都是比较珍贵的材质，可能比蜜蜡一种材质更为珍贵，这样放置的位置可能在棺内，也可能在墓室内的几案之上等。不过多数应该还是随身携带，可见在这一时期依然是十分珍贵。民国蜜蜡时间距离现在太近，所以基本上以传世为主，墓葬中随葬也有见，但整体来看数量比较少。当代蜜蜡不存在出土位置的问题，鉴定时应注意分辨。

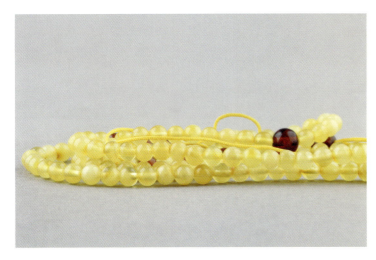

蜜蜡串珠

蜜蜡随形摆件

蜜蜡如意

二、数量特征

 蜜蜡在数量上的特征对于鉴定而言十分重要，可以反映出蜜蜡在一定时期内流行的程度，给鉴定提供概率上的切实帮助。蜜蜡在件数上特征很明确，数量并不多，墓葬出土1～2件为多见。当然并不是所有的墓葬当中都会出土蜜蜡制品，只是偶见有墓葬当中会有出土，多为一些有身份的人在使用。由此数量特征可知，如果大批量的发现古代蜜蜡制品，显然是有问题，这一点无论是商周秦汉还是唐宋元明清都是这样。当然相比之下商周秦汉时期蜜蜡数量最少见，六朝隋唐辽金时期蜜蜡在数量上有所增加，元明清蜜蜡在数量上有进一步增加的趋势，特别是明清时期蜜蜡的数量达到了一个相当的水平，民国基本上延续清代的特征。当代蜜蜡在数量上达到了最高水平，出现了大量的串珠，如项链、手链、佩饰、把件、龙、貔貅、山子、平安扣、隔珠、隔片、念珠、胸针、笔舔、炉、印章、瓶、供器、狮、虎、臂搁、佛珠、水盂、吊坠、如意、桃子、弥勒等都有见。这主要得益于当代原料的易得性，通过进口，可以有大量蜜蜡原石进入中国，这使得蜜蜡在件数特征上进入到中国历史上最为繁荣的一个时期。相信在今日盛世之下，蜜蜡在数量上一定能够再上新台阶，更多人会享受到蜜蜡所带给人们的惬意。

三、完残特征

蜜蜡在完残特征上比较复杂，分古代蜜蜡和当代蜜蜡两种情况。古代蜜蜡残缺比较严重，除了随葬在墓葬当中的制品，其他基本上都没有能流传下来，但磕碰、磨伤、划伤的情况很少见，也就是人为因素比较少见，主要以崩裂、绺裂、腐蚀等环境因素所造成的伤害为主，失亮的情况也常见。因为蜜蜡在各个历史时期基本都是一种贵重材质，古人认为是玉的一种，我们现代人认为是有机宝石，对其都比较珍视，所以人为损坏的情况不是很常见，人们对其保护的措施通常都是比较得当。但是古人将心爱的蜜蜡随葬在墓葬当中，有很多情况就有不确定性了，今天我们所看到的古代蜜蜡品质好坏，主要是看其埋藏环境的好坏。首先是其色彩会有相当程度的变化，因为土壤里如果有朱砂、铁一类矿物，自然会沁红蜜蜡，这也是墓葬当中发现蜜蜡少的原因。或许有的琥珀制品在当年就是蜜蜡的品质，色如蜜、光如蜡，但是到了土里经过腐蚀后，蜜蜡的色泽荡然无存，当然它的物理属性还没有改变，也就是说从蜜蜡变成了琥珀。另外，如蜜蜡项链、串珠等在墓葬当中很快穿系的绳子就会断掉，珠子散落一地，被埋在土里，被地下水浸泡，或者是遭受腐蚀，很快有的珠子就找不到了，或是损坏严重，这样蜜蜡串珠缺失了珠子，也就残缺了，但通常情况下残缺不是很严重。还有一些在墓葬当中很难辨别外形，已经不可能复原，属于严重残缺。

从时代上看，商周秦汉蜜蜡完整者有见，但残缺者更多。墓葬出土的印章等完整者有见，这可能是由于印章比较小，器物造型又是一个整体，所以得以偷生。但大多数早期蜜蜡制品存在着各种各样的残缺。另外，还有字迹模糊的情况，这与表面容易氧化的性质

蜜蜡随形摆件　　　蜜蜡随形摆件　　　蜜蜡随形摆件

有关。六朝隋唐辽金蜜蜡完整器有见，数量也不少，因为这些器皿多数是随葬在墓穴当中，而墓穴是一个相对狭小的环境，一些散落的串珠、项链等，珠子和散件比较容易找到，也比较容易复原，而如果是遗址之上，早就找不到了，因为地层历代可能都有扰乱，基本不能复原。另外，残断、崩裂、划伤等情况有见。宋元明清时期完整的蜜蜡数量最多，在诸多收藏机构中我们都发现了数量众多的毫无瑕疵的蜜蜡。这种情况在其他时代的蜜蜡中很少见，主要限于明清时期，这与明清时期距离现在时代比较近有关。特别是清代有许多都是传世品，人们特别珍视蜜蜡，通常情况下保存得都比较好。

从残缺上看，宋元明清蜜蜡残缺者有见，严重残缺的情况有见，有很多都已经不能恢复原形，碎了，难以复原，但这种情况在数量上显然不占主流。从散落上看，宋元明清蜜蜡穿系串珠的绳子通常撑不了多久，很快就会散掉。有的时候能够全部找到，但有的时候个别找不到，如果找不到显然就是残缺，能够找到再用当代鱼线或绳子穿系，从这个特点上看，基本上我们现在看到的蜜蜡串珠或者是项链等都是现在重新穿系起来的。从绺裂上看，宋元明清蜜蜡中有绺裂的情况，通常不是很严重，但的确是有见，至于形成的原因可能是多种，不再赘述。从磨伤上看，宋元明清蜜蜡磨伤的情况极少，其实无论当代还是古代蜜蜡都是珠宝，很少见到人为伤害磨伤的情况。民国与当代蜜蜡基本上完好无损，民国时期蜜蜡十分珍贵，数量也不多，人们十分珍视，所以保留了下来。当代蜜蜡在这一点上更是比较好，基本上都是完好无损的，这与其商品的属性有关，因为是商品，所以在品相上必须保证非常好，而且数量大，当代蜜蜡的数量可能超出古代发掘器物的总和。鉴定时应注意分辨。

蜜蜡随形摆件

蜜蜡随形摆件

清代红玛瑙卧狮

四、伴生情况

伴生情况多数是指古代蜜蜡。伴生指在墓葬出土时和蜜蜡一同随葬的器物，也就是一同出土的器物。这对于判断蜜蜡的质地、功能等都有着重要的意义，是鉴定方法的一个重要方面。通常情况下与蜜蜡伴生的多是玛瑙、琥珀、翡翠、玉器、红木、瓷器等。由此可见，都是一些珠宝类的质地，瓷大多为名瓷，红木通常为念珠等，琥珀、玉器等也都是串珠、印章类的造型为多见。这说明墓主人具有雅好，非常喜欢这类物品，所以一般情况下很少单独出土。翡翠大多是清代随葬，再早的时代里随葬翡翠的情况很少见。古人实际上是将玛瑙、蜜蜡、翡翠放在同一地位之上，这涉及古人对于玉质的认识问题。第一种观点认为只有软玉才是玉，而第二种观点则认为，凡是具有坚韧、润泽、细腻等质地的美石都是玉，包括硬玉（碱性辉石类矿物组成的集合体，如翡翠）和其他质地的宝玉石（如玛瑙、岫玉、蜜蜡、琥珀）。这样的观点在今日的民间广为流传，此观点与古人的观点也是不谋而合。汉代许慎《说文解字》称玉为"石之美有五德"，所谓五德即指玉的五个特征，凡具温润、坚硬、细腻、绚丽、透明的美石，都被认为是玉。这样看来玉器的概念十分宽泛，这种概念使我们知道了蜜蜡在古人的心目中究竟是玉器还是珠宝之类。看来，古人看待蜜蜡和我们当代是不一样的。

从时代上看，商周秦汉蜜蜡在当时都被认为是玉，这一点显而易见。在一些墓葬当中的确发现一些蜜蜡质地的制品，有的报告定义为琥珀，有的定义为蜜蜡，但无论是哪一种定义，这说明蜜蜡显然是有可能在那一时期被人们所把玩的。六朝隋唐辽金时期的蜜蜡基本上都是作为一种装饰存在，与其伴生的器物也都是此类。六朝隋唐辽金时期与蜜蜡伴生出土的器物很多，如玛瑙、琉璃珠串珠等，基本上以珠宝类为主。宋元明清时期与蜜蜡伴生的器物十分常见，当然伴生有一个范围，就是相伴左右的器物，距离比较近，而这些器物多是串珠、印章、文房等。宋元时期出土器物还是很少见，明清时期逐渐多了起来，如项链、山子、花插、佛手、印章等都有见，不过虽然器物造型多一些，但基本上还是在秉承着传统。民国蜜蜡基本上不存在墓葬伴生情况，但存在着与其质地接近的器皿共同出现在市场上的情况。如与琥珀、银饰、翡翠、水晶、玛瑙、和田玉、钻石、红宝石、蓝宝石、猫眼、祖母绿、海蓝宝石、托帕石、橄榄石、石榴石、蓝晶石、塔菲石、天青石、欧泊、绿松石、鸡血石、寿山石、绿泥石、珍珠、煤精、砗磲、珊瑚等共同出现。

蜜蜡随形摆件

蜜蜡随形摆件

蜜蜡随形摆件

仿老蜡珠

　　由此，有助于我们可以更加深刻地认识到蜜蜡的性质，就是一种宝石，不存在蜜蜡和琥珀名称之争。在中国即使将概念定义得再清楚，但是在市场上依然是将琥珀和蜜蜡分开来销售，这是中国人特有的从商周以来所形成的文化素养和传承所决定的。明白了这些，我们在逛市场的时候就不会觉得烦躁，不会觉得孤单。因为此刻你在逛市场，那么你此刻就承载着5000年以来的文明，将这些同市场结合，这样才能使我们逛市场的意义更加清晰，也才能使我们站得更高看得更远，从历史的高度来俯瞰一个市场上的蜜蜡制品，乃至与其伴生的诸多质地的珠宝玉石类商品。鉴定时我们要注意从一个鉴定要点得出体会，因为这些体会往往比具体行为更为重要，可以帮助我们进入更高水平的鉴赏境界。

蜜蜡如意

第二节　工艺鉴定

一、穿　孔

蜜蜡无论在古代还是当代主要是作为一种饰品存在，而饰品无论是串珠、项链、手链、挂件，还是吊坠、把件都需要穿孔，进行穿系，以利实用。因此，穿孔在蜜蜡制品当中应用最为广泛。从穿孔的情况可以看到很多历史信息。由于蜜蜡质地比较软，从穿孔的磨损程度可以看到有无使用痕迹，再者也可以从钻孔的技术上断定时代，窥视到当时的技术水平，因此蜜蜡的穿孔特征对于鉴定来讲十分重要。

从时代上看，商周秦汉蜜蜡在穿孔特征上技术已经相当成熟，在新石器时代钻孔技术就已经十分发达，著名的红山文化和良渚文化之中都有着发达的钻孔技术。良渚玉璧基本是正圆形，几乎无缺陷。红山文化三联璧是在一件大的原料之上连续打三个不同大小的穿孔，其技术水平要求极高，但显然红山文化联璧精美绝伦，几无缺陷，显示了其高超的钻孔技术。所以，对于蜜蜡这种质地很软的

蜜蜡串珠

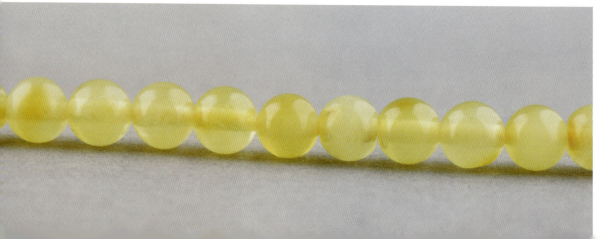

仿老蜡珠

老蜡珠

材质钻孔应该是很容易的事情，这一点毋庸置疑。商周秦汉时期显然在钻孔技术上更为发达，通常都是十分精致。六朝隋唐辽金蜜蜡穿孔较为常见，造型以串珠最为常见，串珠之上的打孔，讲究对称，孔洞圆度规整，非常完美，同时也是非常的自然。对于一些较为复杂的器物，两端打孔的情况多见，但主要还是以打中孔为显著特征。宋元明清蜜蜡在穿孔特征上继续延续传统，同时也有创新。不过这种创新往往伴随着复杂化的过程，打孔不仅仅是为了实用穿系之用，也有可能是为了配合造型或者纹饰而进行打孔。如用打孔来代替羊的两只眼睛等，非常巧妙地将穿孔同诸多特征联系在一起。民国与当代蜜蜡在穿孔特征上基本延续传统，穿孔依然是非常规整，但有区别的是当代蜜蜡上的穿孔多数是机器打的，同一型号的机打孔洞完全一致，整齐划一。这是当代孔洞的特点，而古代的穿孔由于是人工钻，虽然说是非常标准，但如果仔细观察，还是可以观察到人工钻孔的痕迹，这是机器钻孔所不具备的。但是当代机器钻孔的确是提高了生产效率，出现了比任何一个时代都多的蜜蜡珠子等有打孔的造型。我们在鉴赏时应注意区别古代和当代蜜蜡在钻孔技术上的异同。

老蜡珠

仿蜜蜡筒珠

仿老蜡珠

蜜蜡如意

二、打 磨

打磨是蜜蜡做工的重要环节，蜜蜡也是不打不成器。蜜蜡的原石不打磨的时候非常难看，就像外面包裹了一层土一样，而一旦通过打磨，则光滑、润泽，如同小孩皮肤一般的光润，通体闪烁着非金属的淡雅光泽。通常情况对于蜜蜡的打磨都十分仔细，这与蜜蜡材质的珍贵性有关，而且无论古代还是当代在蜜蜡上都是这样。另外，蜜蜡的硬度非常低，比较容易打磨，所以这就造成了无论市场上还是博物馆中的古代蜜蜡，在打磨上看起来都是几无缺陷，没有瑕疵，这其实也是由其固有的物理性质所决定，我们在鉴定时应注意分辨。从时代上看，蜜蜡的发展经历了漫长的岁月长河，对于蜜蜡的打磨不同时代有着不同的特点。商周秦汉蜜蜡在打磨上精益求精，从发掘出土较多一点的汉代蜜蜡制品上看，多数器皿打磨都是全方位的，基本上不留死角。在打磨上以手工为主，辅以脚踏的砣轮，将蜜蜡打磨得光滑、莹润，蜜蜡最美的一面呈现了出来，使得蜜蜡在秦汉时代成为了世间最美的物质之一，所以常被随葬于墓葬当中。蜜蜡不同于一般器物，造型都比较小，但就是这比较小的造型，也被打

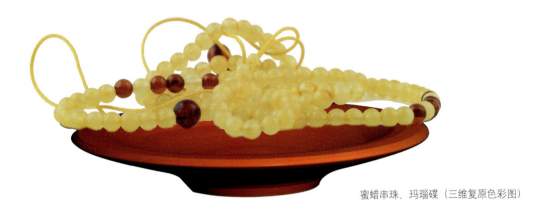

蜜蜡串珠、玛瑙碟（三维复原色彩图）

磨得几无缺陷，精美绝伦。六朝隋唐辽金蜜蜡在打磨上也是极尽心力，非常漂亮，打磨非常仔细，砣轮、手工都有见使用，但是有些太小的器物基上是手工制作，圆度规整，精美至极。宋元明清蜜蜡在打磨上延续传统，几无缺陷，彰显了其高超的打磨技艺。民国蜜蜡在打磨上依然延续传统，打磨仔细，将蜜蜡色如蜜、光如蜡的效果都打磨了出来，明清蜜蜡制品传世品较多，从这些传世品上可以看到打磨极为细腻，纹饰线条之间、线条边缘等地方打磨得都相当仔细，鉴定时应注意分辨。

蜜蜡摆件

蜜蜡摆件

老蜡珠

蜜蜡如意

当代蜜蜡对于打磨相当重视，我们知道当代由于蜜蜡在原料上的便利，大量波罗的海沿岸国家的蜜蜡原石进入我国，所以蜜蜡制品比以往时代总量还要多，因此打磨的任务也相当重。如果是在古代这是几乎不可能完成的工程。但对于当代来讲，在科技力量的支撑下打磨蜜蜡这算不了什么，所以我们观察当代蜜蜡的打磨几乎都是非常好，整齐划一，这显然就是机械化带来的优越。但当代蜜蜡在打磨的细节上有时不如古代蜜蜡，对于一些特殊的器物造型，比如有的是镂空雕，有的是机械达不到的地方，由于量比较大，加之成本问题，所以在打磨上往往就容易出问题，这与古代蜜蜡极为重视细节，不放过任何死角，显然是背道而驰的。因此，当代蜜蜡打磨在取得量的同时，也应该反思。而反思的重点就是在机械力量达不到的地方打磨也要仔细，机械和手工相结合应该是其未来的发展趋势。这样才是传统与创新的结合，不然创新是有了，但是传统也丢光了，这不是我们所要的创新，这一点我们在鉴定时应注意分辨。

蜜蜡串珠

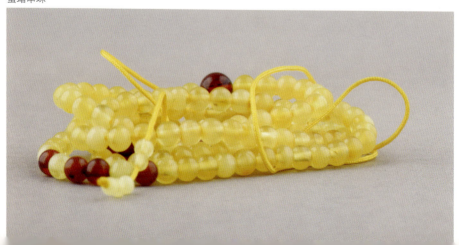

三、使用痕迹

蜜蜡制品在使用痕迹上的特征有很多,如表面包浆、色彩、磨损等,诸多方面都能够反映蜜蜡的使用痕迹,这一点无论古代还是当代都是这样。商周秦汉蜜蜡在使用痕迹上特别明显,由于过于久远,出土的蜜蜡制品在色彩、包浆等各个方面都有很明显的变化,如色彩变得更深,包浆明显,腐蚀严重等,都是判断这一时期蜜蜡在使用痕迹上的特征。但由于这一时期的蜜蜡出土实在是有限,所以很难整理出具体的特征,我们在鉴定时只能从大的方向上把握一下,之后再从别的鉴定要点进行突破。但是其穿孔磨损的程度是可以作为标准的,如汉代墓葬当中经常发现的印章,上面都有穿系的绳子,当然绳子早就化为乌有了,只留下穿孔部位有绳子磨损的痕迹。如果看到这些痕迹,显然证明这就是一件使用过的印章。六朝隋唐辽金蜜蜡在使用痕迹上主要也是看色彩、包浆、磨损,通常情况下色

蜜蜡摆件

蜜蜡摆件

老蜡珠

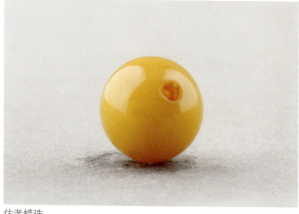

仿老蜡珠

彩变深、有包浆、穿孔有磨损，磨损的程度主要看是什么样的器物，如印章经常带着，自然磨损就比较严重。宋元明清蜜蜡在使用痕迹特征上基本与前代很相似，因为蜜蜡的功能没有改变，基本上还是作为陈设装饰品的功能出现，相当多的蜜蜡制品都是生前佩戴，死后随葬，所以使用的痕迹不可避免，在鉴定时我们要仔细查找，如色彩、包浆、磨损、铭文等。从民国时期的蜜蜡来看，蜜蜡制品在使用痕迹上与前代很相似，基本上没有太大的变化。从当代蜜蜡上看，当代的蜜蜡制品由于数量相当多，市场上的蜜蜡制品应该是没有使用过的多一些，而使用过的少一些，不过在这一点上作伪的人不多，因为蜜蜡只能是经过佩戴后越养越好。很少人会用养过的蜜蜡来冒充新蜜蜡，但他们会用来冒充老蜜蜡，这一点是显而易见的，规模化的找很多人，不停地进行揉搓，冒充老蜡。但这种情况破绽也很多，因为蜜蜡的盘玩不是一朝一夕的事情，一般的情况下，短时间很难盘玩出老蜡的样子，但这一点我们在鉴定时应引起特别重视。

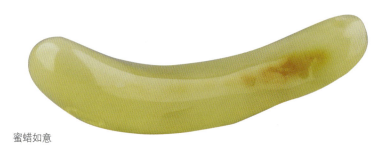

蜜蜡如意

第二节 工艺鉴定 **47**

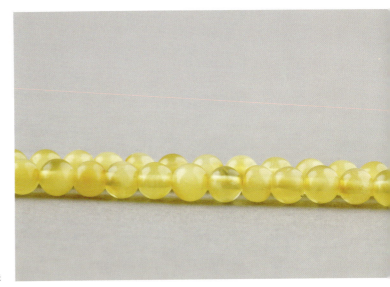

蜜蜡串珠

仿蜜蜡筒珠

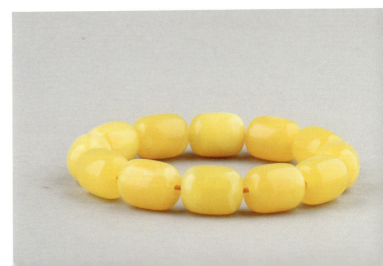

仿蜜蜡筒珠手串

四、镶 嵌

蜜蜡用来镶嵌非常普遍，镶嵌在蜜蜡工艺上占据着相当重要的地位，古代和现代都有。古代以明清时期为常见，一般的镶嵌这一时期都有见，如金、银、玉、水晶等都有见，器物造型如戒面、项链、吊坠、冠饰、簪子等都有见；高古时期在镶嵌上也有见，但不如明清。但明清镶嵌在数量和规模上均不如我们当代，当代蜜蜡在镶嵌工艺上可以说是达到了历史最高峰。镶嵌的材质有大幅的增加，如琥珀、翡翠、水晶、玛瑙、和田玉、钻石、红宝石、蓝宝石、猫眼、祖母绿、海蓝宝石、托帕石、橄榄石、石榴石、蓝晶石、塔菲石、天青石、欧泊、绿松石、珍珠、珊瑚等都有可能和蜜蜡镶嵌在一起。器物造型也更加广泛。但基本上还是以戒面、吊坠、项链、挂件、耳钉等为主，而且数量特别多，从形状上看，蜜蜡被做成橄榄形、椭圆形、各种花形等各种造型，鉴定时应注意分辨。

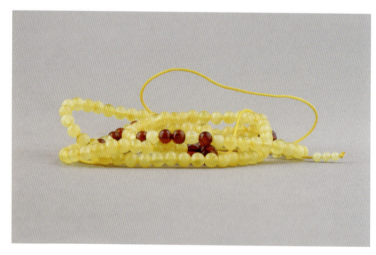

蜜蜡串珠

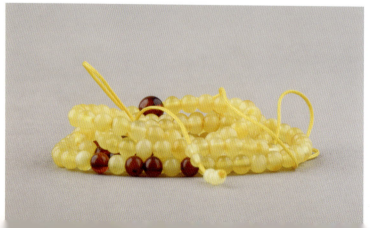

蜜蜡串珠

蜜蜡如意

五、纹 饰

蜜蜡在纹饰上特征相当明显。蜜蜡主要是以色如蜜、光如蜡取胜，但由于蜜蜡质地比较软，在蜜蜡之上雕刻纹饰犹如在纸上绘画，所以在蜜蜡之上装饰纹饰也是蜜蜡的重要特点。纹饰主要以刻画纹为主，浮雕和浅浮雕为辅，镂空等特殊的工艺也是常见，总之是将蜜蜡雕刻得繁花似锦、精美绝伦。

从纹饰题材上看，蜜蜡从古至今纹饰题材特别丰富，常见到的主要有龙纹、蔷薇、梅花、兰花、树木、蕉叶纹、叶脉纹、竹、果蔬、瑞兽、鱼纹、牛纹、虎、豹、兔、鹿、驼、狮、蝙蝠、鸭、鹅、鸟纹、鸳鸯、燕、喜鹊、鹤、蛙、蜻蜓、蝴蝶、蝉、生肖、侍女、八仙、弦纹、花卉纹、瓜棱纹、舞狮、渔翁、婴戏、诗文、山石、历史故事、神化故事、博古纹、合和二仙、杂宝、吉祥图案、观音、弥勒、佛教题材、道教题材、波浪、海水江牙、花草、仰莲、覆莲、缠枝莲、折枝莲、其他莲瓣纹、宝相花、柿蒂纹、牡丹、忍冬等，由此可见，蜜蜡在纹饰题材上的确是十分繁盛。但我们也可以看到这些蜜蜡上的纹饰多数为传统的延续，就是说除了蜜蜡上有这些纹饰题材外，

蜜蜡如意

蜜蜡如意

其他质地的器物之上也有见，如琥珀、玉器，甚至瓷器等都会有见，因此说明历代蜜蜡在纹饰题材上借鉴的成分的确是比较多，在纹饰题材上创新比较少，主要是以题材的不同组合方式，以及契合于蜜蜡质地的纹饰为主要创新点。如清代中期常见蜜蜡佛手的造型，这种佛手契合了多种内涵，是自然界的一种花卉，同时也契合了佛教方面的某些涵义。但是这些内涵都不易用语言表达，蜜蜡就用了纹饰，通常是在纹饰之上再雕刻一些花卉，以衬托佛手。有的仅仅是雕刻一些枝脉，如刻画一些线条等；有的是雕刻一些比较神秘的动物，如蝙蝠等，纹饰就是在这一系列的设计构思中充当引线的作用，将各个方面的因素串联起来。在一件雕件之上你会发现，纹饰一会儿衬托造型，一会儿又衬托寓意等，这应该是蜜蜡在纹饰上最本质的特征，我们在鉴定时应该能够理解。

　　从构图上看，蜜蜡在纹饰上构图繁复与简洁并存，这可能是由于不同时代人们对于纹饰的不同需求所致，其实如果我们对于蜜蜡纹饰做统一的分析，显然蜜蜡在纹饰上也就是分为几类，如弦纹、几何纹、花卉纹、草叶纹、人物、瑞兽、山石等，但是在这些纹饰之下还会衍生出诸多不同的衍生性纹饰，如弦纹会衍生出一周凹弦纹、两周凹弦纹、三周凹弦纹、多周凹弦纹、环饰凹弦纹、不规则凹弦纹、凹弦纹、隐约凹弦纹等；几何纹可以衍生出同心圆纹、羽毛纹、网格纹带、波浪纹、篦纹、凸印纹、附加堆纹、海浪纹、齿纹、刻划纹、锯齿纹、条线锯齿纹、回纹、刻锯齿纹、一周锯齿纹等；

草叶纹可以衍生出劲草、蝈蝈戏草、卷草纹、印四组卷草纹、叶纹、叶脉纹、花叶纹等；花卉纹可以衍生出枝花、刻划枝花、一枝花卉纹、不知名雕刻花卉纹、菊花纹、缠枝菊花纹、缠枝花卉纹、折枝花卉纹、篦纹折枝花、花瓣纹、花之间刻枝蔓纹等。由此可见，其实蜜蜡纹饰本身并不繁复，只是相互组合在一起时就显得比较繁复了，同时简洁的纹饰也存在，如清代的一些佛像雕刻，纹饰在雕刻上的作用就是寥寥几笔勾勒出菩萨衣服皱折和轮廓，显得十分简洁，鉴定时应注意分辨。

从时代上看，商周秦汉蜜蜡在纹饰种类上也是十分丰富，在纹饰题材上主要是借鉴商周青铜器、玉器之上的纹饰，如同心圆、弦纹、羽毛纹、绳纹、乳丁纹、网格纹、锯齿纹、蕉叶纹、水波纹、联珠纹、兽纹等应该都有见，但商周秦汉发现的蜜蜡很少，但从理论上分析基本上题材就是这样，结构合理、简洁明了、韵律自然、刚劲挺拔，可见其技法之娴熟。六朝隋唐辽金蜜蜡在纹饰种类上特征比较明确，弦纹、网格纹、锯齿纹、蕉叶纹、水波纹、联珠纹、兽纹等都有见，线条流畅，雕刻凝练，图案讲究对称，构图合理，一般以简洁为主，有纹饰的蜜蜡制品并不是很常见，看来在六朝隋唐辽金时期，蜜蜡并不是以纹饰取胜。宋元明清蜜蜡在纹饰上逐渐丰富起来，特别是明清时期蜜蜡纹饰真正走向了繁荣，形成了造型、工艺、纹饰并重的蜜蜡制作工艺，纹饰繁简并举，有单独的一种纹饰。如宝相花多为浅浮雕，中间一个主纹，两侧为辅纹，讲究对称。但由于是手工刻划，纹饰之间总是或多或少地存在着细微的差异，如两朵花之间相像，但不完全相同，纹饰线条之间长短、用力、粗细等不完全相同。另外，装饰纹饰的部位也比较复杂化，较为多样化，琥珀杯的外壁、笔筒的外壁、鼻烟壶的外壁等，而且一般都占得比较满，特别是一些戒面之上有的也刻划有纹饰，可见这一时期纹饰在蜜蜡之上的应用之繁盛。

蜜蜡如意

民国与当代蜜蜡在纹饰上特征相当明晰。民国时期基本延续传统，变化很少，创新更是凤毛麟角。当代蜜蜡数量众多，为蜜蜡纹饰创作提供了广阔的天地，可以说是集大成。几乎所有的纹饰题材在当代蜜蜡雕件之上都有见，特别是花卉纹、动物纹、人物故事、婴戏、生肖、侍女、八仙、历史故事、神化故事、博古纹、合和二仙、杂宝、吉祥图案、观音、弥勒、佛教题材、道教题材等出现的频率很高。从写实性上看，当代蜜蜡纹饰主要以写实性为主，但讲究意境，如鼻烟壶的外部可能就是比较繁复的纹饰，如松下童子，必然会将童子的外貌刻画的很清晰，使童子的外貌没有悬念，之后才是嬉戏的场面，山林、树木，或许还有草地等。实际上，这些场景中的童子、树、草等现实中都有，但婴童天真烂漫，以及现代人和古代人物的不确定性，以及山林之隐的畅快淋漓是现实社会当中不曾有的，是人们的一种理想状态。而这就是当代写实性作品，写实但讲究意境的内涵。我们在鉴定时应注意分辨。

另外，当代蜜蜡在纹饰上成功产生了较为大型的全景式的立体雕件，以山子、墨床、其他摆件为主，往往是画面复杂，表现人物众多，动感强烈。往往描述的是一个场景，或是一个故事，甚至是连续的故事和场景，动感和生命感都极强，栩栩如生。山子层峦叠嶂，亭台隐于山林之间，构图合理，对比强烈，传统的绘画艺术与立体的蜜蜡雕件在一起，全景式的立体雕件有着平、深、高等多层次的艺术效果，且比例尺寸掌握得十分恰当，历代理想中的全景式雕件在

蜜蜡如意

当代都出现了，可见当代蜜蜡在纹饰上的繁荣。当然，这与当代科技在蜜蜡雕琢上的应用也有关系。当代纹饰的雕刻大量使用了机雕，就是用机器进行雕刻，在电脑上设计好图纸，机器就可以按照图纸轻松地雕刻出纹饰图案，再复杂的图案也就是轻按鼠标就可以了。这样来看当代纹饰的繁荣与纹饰雕琢用机器雕也有关系，不用耗费太多的人工，所以到处都可以看到纹饰。这在以往任何时代都不可能，因为仅仅是人工就不够用，因此我们在看到当代纹饰的繁花似锦的同时，也要看到原因。机雕纹饰的优点是，几无缺陷，和电脑上的模板是一样的，避免了因手工雕刻所带来的不确定性；但缺点也很明显：千篇一律，纹饰图案都一样，直接省略了在雕刻过程中的所思所想。正是因为这样，当代最为顶尖的作品，并不是用机雕的纹饰，而是打磨抛光等使用机器，像雕刻等还是使用人工，多数由工艺美术大师来进行雕刻，手工与机械相结合、古代与现代相融合。当然这样的作品也是当代最好的。

六、文 字

蜜蜡制品有纹饰的情况常见，如印章上有印文，这是必需的，其他的吉语文字也有很多。但早期以印文为主，如秦汉时期多以印文为主，当然印文也有吉语，如"常乐富贵"等。六朝隋唐辽金时期基本与前代差不多。宋元明清蜜蜡在琢刻文字上基本还是以印文为主，但配合纹饰的倾向已经比较明显，如一面纹饰一面文字，如"瑶池春熟"等都常见。实际上在明清时期诗文与蜜蜡的结合已经十分明晰，如在鼻烟壶上刻上一首诗词，这是非常普遍的情况。民国时期基本上延续清代，创新不是很多。当代蜜蜡制品在文字上比较丰富，常见箴言，如平安扣之上有一周篆刻文字的箴言，这都很常见。再者就是吉语、诗文等，佛教题材的字纹也有很多，就是以字为装饰，如手串的每一个珠子之上都有佛字，还有生肖等牌上也喜刻上生肖的名字。总之，当代文字在蜜蜡上的使用可谓是不胜枚举，题材、内容、形式都太多，当代真正是实现了文字琢刻的扩大化和随意化，题材新颖，内容丰富。但是当代文字实用性并不强，主要是装饰性比较丰富，如当代的许多蜜蜡印章并不是真正的印章，只是做成印章的样子，供人们欣赏而已。这类印章当然没有印文，这一点我们应能够理解。

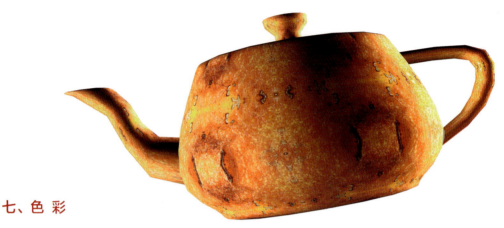

蜜蜡执壶（三维复原色彩图）

七、色 彩

蜜蜡在色彩上十分丰富。实际上，蜜蜡的本色只有一种黄色，这一点很容易理解，就是因为松脂等是黄色的，本身可能只会出现浅黄、深黄等的变化。但是造化弄人，实际上蜜蜡在色彩上并不都是色如蜜，蜜蜡的名称也不是简单的顾名思义，只是一个名称而已。蜜蜡常见的色彩有金黄、红色、枣红、橘红、蓝色、深红、蓝紫、米色、紫红、青色、褐色、米白色、红色略泛褐、鸡油黄、白色、棕色、黑色、蛋青色、紫色、绿色、咖啡色、浅黄、土色等。这些色彩包括老蜜蜡。由此可见，蜜蜡在色彩上是相当丰富，涉及了众多的色彩类别。但这些色彩主要是由于埋藏环境的不同所造成的，如埋藏环境内有铁或者朱砂一类的色彩，那么有可能蜜蜡受到沁染后就可能由其本色黄色变成为棕红、铁红、枣红等。总之环境不同，或者是风吹雨淋，蜜蜡都有可能变成各种各样的色彩。人们还根据这些色彩将其定名，如将白色的蜜蜡称为白蜡；将年代久远的，红色、枣红、橘红、深红、蓝紫、褐色、棕色、紫色、蓝色等称为老蜡。由此可见，老蜜蜡在色彩种类上显然是各类蜜蜡之最。还有将金珀和蜜蜡共体称之为金绞密；琥珀和蜜蜡共生体称之为半蜜半珀等。称谓不一定科学，但的确是有这种说法。实际上蜜蜡和琥珀本身就是一种物质，只是人们在把玩时人为地将琥珀和蜜蜡分开而已，如果有人试图将琥珀和蜜蜡截然分开，那等于说是错误理解了琥珀和蜜蜡的区别，关于这一点不再过多赘述。从数量上看，市场上蜜蜡数量显然是色如蜜者多，以黄色基调为主，如金黄色、浅黄色、橙

黄色、蛋黄色、棕黄色、鸡油黄等色彩为主。由此可见，黄色的蜜蜡显然是各种蜜蜡当中数量最多者，这一点我们在鉴定时应注意分辨。老蜡的数量在蜜蜡当中并不算是很丰富，只能说是有一定的量，而且是总量，因为各种单独的色彩，老蜡每一种都比较少见，但从价值上看，老蜡是最高的。从产地上看，古代蜜蜡主要产自缅甸、巴基斯坦、中国西藏等，但是当代蜜蜡，特别是黄色基调的蜜蜡多产自波罗的海沿岸国家，如近些年来比较流行的鸡油黄等的蜜蜡这一地区产量就特别大。但也不是像我们想象中的那么大，因为矿产资源，特别是像蜜蜡这样的化石，真正放开开采也开采不了几年。这一点我们在鉴定时应注意数量这一特征，如果发现过多而又便宜的蜜蜡，我们要小心，先检测验明是不是仿造的。有时会有人声称与波罗的海沿岸国家有关系，可以找到很多的蜜蜡原石。其实，这些国家有很多好的矿也是限制开采的。例如乌克兰只有一家国有控制的公司开采蜜蜡，基本以黄色调为显著特征，但这家公司每年开采多少都是有计划的，而并不是无序的开采，整个的手续都很麻烦，所以蜜蜡原料整个来讲还是比较紧张，不像市场上我们看到的那样多。这些背景信息显然也是我们在鉴定时所必须要了解的，这样可以给我们宏观上的一个指导。从时代上看，蜜蜡色彩在时代特征上鲜明，商周秦汉时期蜜蜡在色彩上比较单一，主要以深色调为显著特征，而随着时间的推移，蜜蜡色彩逐渐在丰富，到明清时期几乎所有的蜜蜡色彩都有见，直至当代蜜蜡色彩达到极为丰富。从精致程度上看，蜜蜡色彩与精致程度有一定的关系，枣红的色彩有可能是老蜡，自然珍贵，通常制作的精致程度也就高；而浅黄色的蜜蜡，由于数量比较多，所以基本上以普通和粗糙的器物为多见。从渐变

蜜蜡随形摆件

蜜蜡随形摆件

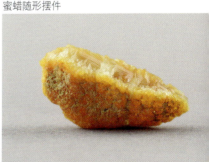

蜜蜡随形摆件

色彩上看，蜜蜡真正纯正的色彩非常稀少，蜜蜡色彩的纯正程度总体并不是很好。多数蜜蜡在色彩上有微小的渐变过程，就是局部从一个色彩演变到另外一个色彩。但是极为细小的演变，并不会影响到对于整个蜜蜡色调的认定，当然这是蜜蜡在色彩上所固有的特点。从色彩的名贵程度上看，老蜡的色彩是名贵的，但由于时代的关系，老蜡数量很少，其色彩的名贵程度并未对市场造成太大的影响。真正在当代市场上影响大的色彩是不断变化的。如过去可能认为黄色是不值钱的色彩，但近些年来随着蜜蜡的普及，黄色调当中的某些色调只要是契合了人们某种情感，其色彩就会变得名贵。如鸡油黄色近些年来的表现就非常不俗，优质者绝不输于老蜡的价值，成为市场的新宠，正在改变着黄色的蜜蜡不值钱的过时说法。鉴定时应注意。

蜜蜡随形摆件

蜜蜡随形摆件

蜜蜡随形摆件

蜜蜡摆件

蜜蜡随形摆件

蜜蜡随形摆件

仿蜜蜡筒珠

八、做 工

　　蜜蜡在做工上非常好，各个历史时期在做工上都是精益求精，极尽心力。而做工是古蜜蜡鉴定的重要手段，要将硬度很大的蜜蜡制作完美，是件非常难的事情，需要精益求精、一丝不苟的态度。因此做工辨伪是古蜜蜡辨伪中最重要的一个环节。不同时代、地域、功能的蜜蜡等在做工上都会有差别，这些差别互相渗透，相互影响，组成了一个复杂的鉴定体系。我们在鉴定过程当中要注意把握住主

流，也就是蜜蜡在做工上的高度，这是重要的，因为在某一历史时期内达不到一定水平的蜜蜡通常多是伪器。如明清时期蜜蜡打磨不仔细者则多为伪器，因为明清时期蜜蜡在做工上几乎都是精益求精，工艺精湛之器，在打磨上自然是不会有纰漏。因为蜜蜡的材质本身很珍贵，工匠在制作时特别注意通体打磨。当代蜜蜡在打磨上也是没有任何问题，因为机器打磨，几乎所有的地方都打磨非常光滑，但在机械无法打磨的地方我们要注意它的打磨情况，有的打磨明显有问题。蜜蜡在做工上各个历史时期在态度上都是比较好，很少出现因为态度问题而在做工上有问题的，包括当代的蜜蜡也是这样，在态度上都是非常认真。但有一个情况就是有的时候由于成本的限制，在做工上当代蜜蜡可能有简化的成分。比如抛光的雕件，有的就是打一个孔，随意根据随形雕琢一个佛头。这样的设计虽然可以说是巧妙的雕刻，但是未免有时会有就简之嫌疑。这是当代蜜蜡雕刻作品上的一个不足，我们在收藏时应注意区分哪些是就简的作品，而哪些是真正精致的作品，要有这个能力。在具体的雕刻手法上，无论古今，人们怀着极大的热情将片雕、半圆雕、圆雕、镂雕、浮雕、浅浮雕等，几乎所有的雕刻手法都运用到了蜜蜡之上，可见人们对于蜜蜡的重视程度。而从蜜蜡作品上看，这些手法使用频繁，有的一件作品之上会有很多种方法，如刻划、浅浮雕、浮雕、镂空等并用，雕刻工艺精湛，在纹饰上出现了一些难度较高的浮雕作品，精益求精，几无缺陷。总之，对于一块蜜蜡人们是爱极了，使用阴刻、阳刻、钻孔、画样、锯料、抛光、挖凿等各种工艺手法，对一件蜜蜡进行精雕细琢，显示了蜜蜡制品在工艺上高超的技艺。

蜜蜡随形摆件

蜜蜡摆件

老蜡珠

蜜蜡如意

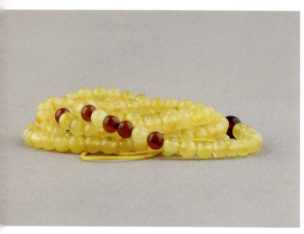

蜜蜡串珠

九、功 能

　　蜜蜡在功能上比较明确。没有证据显示蜜蜡有礼器的功能，也就是象征权力、等级地位的功能。蜜蜡从新石器时代开始就是作为串饰，也就是以装饰品存在。商周秦汉、隋唐宋元，直至明清，乃至我们当代，这一基本的功能都没有改变。但是在时代的发展当中，由于各个时代对于蜜蜡制品所赋予的内涵不同，所以在各个时代里蜜蜡也具有了一些特有的功能。如在汉代，一个重视厚葬的时代里，视死如视生，汉代信奉的黄老哲学，认为人死不过是像搬家一样，从一个世界搬到另外一个世界里去生活，所以蜜蜡除了在生活当中供人们把玩、佩戴、实用外，还具有明器的功能。总之，蜜蜡的功能虽然明确，但相当复杂，常见的功能主要有：实用器、明器、首饰、发饰、佩饰、陈设器、饰品、财富象征、艺术品等，这些功能有的是重合的，有的则是单独存在。如墓葬当中出土印章的功能，起码有这样几种：一是明器，二是实用器，三是饰品，四是财富象征。项链的功能，首先应该是首饰，其次是饰品、财富象征等。总之，不同的器物造型在功能上不同，鉴定时应注意分辨。

第二节 工艺鉴定 **61**

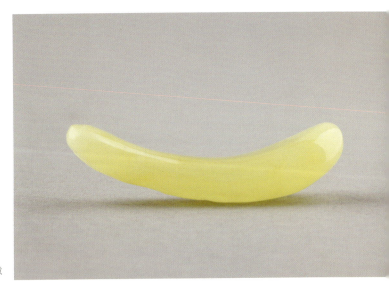

蜜蜡如意

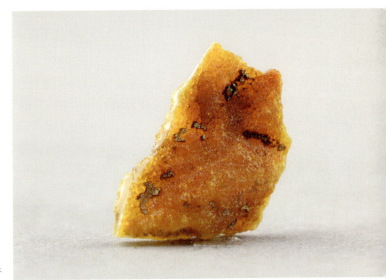

蜜蜡随形摆件

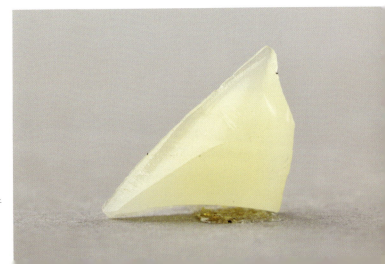

蜜蜡随形摆件

第三章　造型鉴定

第一节　蜜蜡造型

一、综述

蜜蜡如意

蜜蜡常见的造型主要有手镯、胸针、觿、簪、松鹤山子、葫芦、印章、鼻烟壶、项链、手串、老料随形、吊坠、佩饰、狮、虎、臂搁、佛珠、如意、挂件、随形山子、戒指、块状随形、耳环、多宝串、观音、弥勒、佛像、平安扣、隔珠、隔片、把件、龙、老蜡珠、念珠、三通、貔貅、单珠、饼状随形、团状随形、水滴状随形、肾状随形、瘤状随形，筒珠、笔舔、金瓜、瑞兽、婴戏、荷花、组合镶嵌器物等。由此可见，蜜蜡在造型种类上十分丰富，但与翡翠、和田玉相比在造型上还显得单薄。与古代蜜蜡相比，当代蜜蜡在造型上可以说是古代无法比拟的，这主要是由于突破了原材料的限制。当代进口了大量缅甸、特别是波罗的海沿岸国家的蜜蜡原矿，进口量居历代之最，如此丰富的原材料，铸就了当代比历史上任何一个时代都要多的蜜蜡造型。下面我们来看一下蜜蜡在造型上的细部特征。

蜜蜡随形摆件

蜜蜡随形摆件

无时代特征蜜蜡随形摆件

（1）从时代上看，虽然蜜蜡在古代很早就有使用，但由于地域原因，因为国内很少产蜜蜡，主要在国外，所以在古代进口非常不易，加之和田玉独大的局面古已有之，所以蜜蜡在古代数量有限。较为常见的器物可能就是清代的鼻烟壶了，我们来看一则实例，"鼻烟壶1件。M2：4-2，形为扁体长方形，直颈圆口，圈足"（苏州博物馆，2003）。同一座墓葬还出土了"彩料鼻烟壶1件。M2：4-1，壶形呈扁圆体，直颈较长，圆口圈足，玻璃质地，以细密的孔雀蓝散点为底色。壶腹上凸饰的红色金鱼及红色圈足与壶体浑然一体"。由此可见，清代蜜蜡鼻烟壶和彩料鼻烟壶在造型宏观上具有相似性。如都是圆口、小口等，同为直颈只是在长短上略有差别。蜜蜡鼻烟壶体型为圆形，而彩料鼻烟壶为扁圆形。由上可见，这两件鼻烟壶在造型上区别不大，只是在细节上有些调整。另外，蜜蜡在鼻烟壶上的造型还与同时期的瓷器鼻烟壶等十分相像，相互借鉴的特点浓重，在造型鉴赏时应注意分辨。但基本的造型显然是小口、短颈、丰肩、圆腹或扁圆腹、矮圈足等，其他造型都是在这一基础之上衍生出的微小改变。我们当代鼻烟壶在造型上基本模仿清代和民国，几乎没有太大的变化。当然，这可能与当代的鼻烟壶只是工艺品，而清代的鼻烟壶显然是实用和装饰品的完美结合。因此当代鼻烟壶模仿的气氛较为浓重，我们在辨伪时应注意分辨。

（2）从数量上看，造型在不同时代里出现的频率，反映造型的流行程度。数量对于蜜蜡鉴定可以说起着决定性的作用。蜜蜡整体器物造型在古代出现较之和田玉、瓷器少之又少。清代蜜蜡出现最多的是以串珠、鼻烟壶、挂件为多，特别是以鼻烟壶独大。由此可见，从造型出现的频率来看，早期蜜蜡制品还是以装饰为主，同时结合实用的功能。而当代这种变化不是很明显，虽然在原料来源上通过进口已经不成问题，但是主流造型并没有太大的改变，已经没有任何实用价值的鼻烟壶频繁出现，显然更多的是受到传统的影响。串珠的数量依然庞大，各种手串、项链、挂件等都有见，主要体现出的是串珠的绚丽多姿，从数量上基本占据当代蜜蜡市场的主流。由此可见，传统延续的力量是多么强大，人们在制作蜜蜡之前首先考虑到的是其传统的造型是什么，之后才会在这一基础之上进行创新。可喜的是这种创新在当代已经来临，而这种姗姗来迟的创新也就是近十几年的事情。虽然这些所谓创新的造型同样大多数是借鉴传统，但在数量上初具规模，对于蜜蜡而言就是创新，如手镯、葫芦、老料随形、随形山子、多宝串、观音、弥勒、佛像、平安扣、隔珠、隔片、各种把件等，在数量上比重增加，虽未占据主流，但在造型上成为重要一极。我们在鉴赏时应注意体会。

蜜蜡摆件

老蜡珠

蜜蜡镯（三维复原色彩图）

（3）从大小上看，蜜蜡在大小上的特征比较清晰。我们先来看一则实例，蜜蜡鼻烟壶"壶高8、腹径5.5、口径2.2、底径3.7厘米×1.7厘米"（苏州博物馆,2003），这件清代蜜蜡鼻烟壶我们现在来看非常之小，属于袖珍型的器皿，高度只有8厘米，口径只有2.2厘米，把玩于手掌之上。同这件鼻烟壶一样，在清代蜜蜡由于材料的稀缺性，基本上无大器。当代蜜蜡在原材料的易得性上已经是相当好转，一些较大的器物造型，如山子等频繁出现。但就体积而言，蜜蜡的山子比其他，如和田玉、岫玉、南阳玉等要小很多。其他的物件如手镯、项链、手串、吊坠等基本上能够赶上实用的需要，但是大器很少见；而且观音、弥勒、佛像等多是以吊坠为主，大型摆件的情况很少见。之所以出现这种原因主要有三点，一是传统"惜料"风俗的影响；二是由蜜蜡材料本身大小所致；三是蜜蜡原料珍贵性。我们在鉴定时应注意体会。

蜜蜡随形摆件

蜜蜡串珠

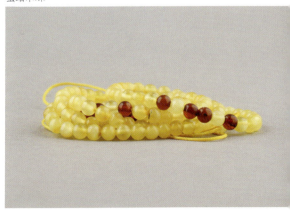

（4）从相似性上看，蜜蜡器物造型在相似性上特征十分明晰。清代蜜蜡鼻烟壶与同时期的瓷质、玉质等材料相似，同样当代蜜蜡也是这样，基本上和琥珀、和田玉、水晶、玛瑙等的造型很相似，显然是相互借鉴的结果。这是其相似性的一方面，另外一种相似性表现在蜜蜡器物造型自身的相互借鉴上。如蜜蜡手串中圆珠、筒珠、隔珠、隔片等的造型变化不大，包括把件、吊坠的造型变化也都不大。总之，固守传统和同类造型的借鉴是其相似性的最主要表现。其原因还是与蜜蜡这一稀有的材质有关，一些设计师也想大胆进行尝试，但真正到了制作的时候还是摆脱不了束缚，就是害怕将一块好料做坏了。这一点我们在鉴定时也要注意。

（5）从功能上看，造型因需要而产生，因为功能而延续，因此通常情况下，在功能不变的情况下，器物的造型很难改变。一旦人们不需要它，一种古蜜蜡造型很容易就消失掉了。蜜蜡造型与功能之间有着一定的关联，蜜蜡之所以会出现这样或者那样的造型，显然是由人们的需要所决定的，也就是由其功能所决定。现在鼻烟壶使用的情况比清代少了许多，这样鼻烟壶在数量上显然就没有那么多了，而新兴起的则是把件和吊坠一类的蜜蜡器皿。如把件，造型比较大，以圆雕为主，这是为了适应人们把玩的需要。而吊坠显然就不能很大，因为如果太重了显然不适合人们佩戴。而且半圆雕和片雕等都有见，造型更加多样化。总之，蜜蜡在造型与功能之间的这些特点，我们在鉴定时应注意分辨。

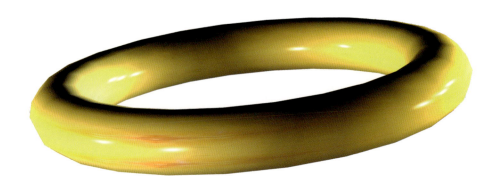

蜜蜡镯（三维复原色彩图）

第一节 蜜蜡造型

老蜡珠

蜜蜡如意

蜜蜡随形摆件

老蜡碟（三维复原色彩图）

（6）从规整上看，蜜蜡造型在规整程度上通常比较好，多是造型隽永之器，包括一个珠子都是精打细磨，造型圆度规整，几无缺陷。当然这与蜜蜡质地比较软，较有利于修整也有关系，有的时候拿砂布自己就可以打磨。从时代上看，蜜蜡造型古代显然比现代要差一些，因为当代蜜蜡多数为机制，机器想要打磨蜜蜡是相当容易的事情，而古代手工就比较困难。当然古代也打磨得很好，但是不可避免会有一些瑕疵。鉴定时应注意分辨。

（7）从写实性上看，蜜蜡造型在造型写实性上分界线很明确。古代蜜蜡写意气氛重一些，而当代则是以写实为主，雕琢以惟妙惟肖为追求，鉴定时应注意分辨。写意作品有见，但多是限于一些工艺美术大师的作品，数量非常少。

蜜蜡随形摆件

蜜蜡摆件

二、老 蜡

　　老蜜蜡常见的造型主要有手链、手串、吊坠、单珠、手镯、觿、饼状随形、老料随形、水滴状随形、肾状随形、瘤状随形、佩饰、挂件、随形山子、戒指、耳环、多宝串、观音、弥勒、佛像、平安扣、三通、瑞兽等。由此可见，老蜜蜡在造型种类上并不算丰富，但也不算是很少，只是与普通蜜蜡相比种类在减少。但事实上以上造型如手镯、山子、观音等只是偶见，或者说理论上应该有，实际在市场上基本看不到。原因很多，但从时代上看，老蜜蜡数量更少的原因是在于老蜡料少见。道理很简单，古代就很少，流传到现在数量就更为少见。以至于目前市场上看到的只是以单珠为主，一些手链和手串已经算是很不容易了。从大小上看，蜜蜡在大小上的特征比较清晰，单珠比较大，当然小的也有，这与古代人们手工打磨蜜蜡的视觉习惯性有关。当然当代老蜜蜡在器物造型上则是比较小，如，单珠虽然大，但很多情况下这个单珠就是整个器物造型。总之，在体积上老蜜蜡以小为显著特征。从时代上看，蜜蜡造型古代显然比现代要差一些。因为当代蜜蜡多数为机制，机器想要打磨蜜蜡是相当容易的事情，而古代手工就比较困难，当然也打磨得很好，鉴定时应注意分辨。从规整上看，老蜜蜡造型在规整程度上有些问题，一些比较好，而另外一些呈现出很多手工痕迹。如算盘珠的造型基本上中孔弄不到中间位置，做工痕迹明显，也有一些较大的珠子，圆度规整谈不上。从相似性上看，老蜜蜡在器物造型上相似性很弱，老蜜蜡由于是手工制作，又历经岁月的洗礼，所以在造型上的细微特点都不相似，但宏观上的造型相似性比较强，同样固守传统和同类型造型之间的相互借鉴。从功能上看，造型因需要而产生，因为功能而延续。因此通常情况下，在功能不变的情况下，器物的造型很难改变。老蜜蜡的造型显然过去因需要而产生，但是当代老蜜蜡的造型，显然珍贵材质象征的功能更多一些。如一看到不规则的大珠子，人们自然会兴奋不已，找到了一颗老蜜蜡。原因就是它是老蜡的代表性特征之一。可以想象如果是新蜡做成这个样子，那么显然为残次品了，这种造型与功能之间的关系，我们在鉴定时应注意把握。

老蜡碟（三维复原色彩图）

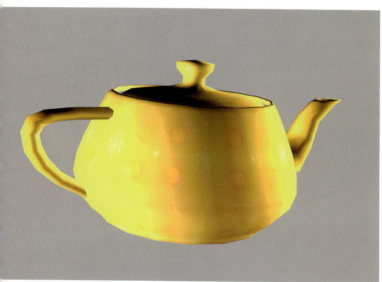

老蜡执壶（三维复原色彩图）

老蜡珠

三、浅黄蜜蜡

　　浅黄色蜜蜡常见造型主要有秋叶、饼状随形、手串、吊坠、水滴状随形、瘤状随形、单珠、手镯、觿、肾状随形、佩饰、挂件、戒指、耳环、多宝串、观音、弥勒、佛像、平安扣、瑞兽等。基本上蜜蜡主流的造型浅黄色蜜蜡都有了。但是我们发现，古代蜜蜡很少见有非常鲜亮的浅黄色，这与其时代有关。因为蜜蜡本身在色彩上的稳定性不是像和田玉那样的稳定。如果埋藏在土里，它的颜色会随着矿物质如铁、朱砂等色彩而变成黄棕色、枣红色，或者在太阳光下长期的暴晒，雪地里埋，风吹雨淋等都会变色。所以，假定古代人们佩戴的蜜蜡是浅黄色的，那么在历经岁月的洗礼之后，蜜蜡在色彩上也会有相应的变化。当然，多数是受到污染变成其他的颜色。因此对于浅黄色蜜蜡我们要辩证地看问题，如果见到明清时期的蜜蜡鼻烟壶等是浅黄色，那么也要谨慎对待，先辨明真伪。从出现的频率上看，浅黄色的蜜蜡在种类上出现的频率各不相同，以串珠、散珠、秋叶、戒指、耳环、挂件为多见，等于说多是以小而简单的器物为主，而如手镯、佛像、弥勒、观音、瑞兽等大件或者制作难度大的器物出现的频率并不高，总量有限。这一点与当代对于蜜蜡的认知有关，由于受到老蜡的影响，许多人认为色深的蜜蜡

蜜蜡随形摆件

72 第三章 造型鉴定

蜜蜡随形摆件

蜜蜡随形摆件

蜜蜡摆件

是好蜜蜡,而色彩浅的不是好蜡,这样将浅黄色蜜蜡归入了误解之中。而实际上,浅黄色的蜜蜡是距离蜜蜡本色最近的种色之一,因为蜜蜡的本色唯一就是浅黄色,是由于受到各种化学反应和土壤中的矿物质沁染,才变成了红、橙、蓝、紫、白、黑等多种色彩。因此浅黄色实际上应该是一种很好的蜜蜡色彩,这一点相信从市场上不断增多的产品可以看到,很多人已经认识到这一点。从大小上看,浅黄色的蜜蜡相比较老蜡而言显然比较大气,很多较大的器物造型都是浅黄色的,这可能与浅黄色蜜蜡的原材料比较易得有关。从规整上看,浅黄色的蜜蜡在规整程度上比较好,圆度规整,弧度圆润,但机制痕迹还是比较浓重。当然也有很多是机械和手工雕刻共同作用于一件作品上,打磨通常比较仔细。从相似性上看,浅黄色蜜蜡在器物造型上相似性很强,因为浅黄色蜜蜡多数是当代开采的矿料,波罗的海沿岸国家进口比较多见,加之机器制作、抛光等,所以在造型上比较相似。如珠子粒粒基本相似,在大小、造型上等都相似。当然这是浅黄色蜜蜡的一个特点,但并不是一个不好的特点。因为整齐划一同样是一种美;同时在造型上很少同质化的造型显然是相互借鉴的结果,所以在造型上浅黄色的蜜蜡同样固守传统和同类型造型之间的相互借鉴。从写实性上看,浅黄色蜜蜡造型写实性比较强,写意的功能较为弱化。从功能上看,浅黄色蜜蜡造型的产生,满足了人们对于美的需求,主要以实用和装饰的造型为主,如手串等,既可以佩戴,又非常的美观。

老蜡执壶(三维复原色彩图)

蜜蜡执壶(三维复原色彩图)

"娇黄"瓷器标本·清代

四、鸡油黄蜜蜡

鸡油黄蜜蜡常见的造型主要有手链、手串、吊坠、单珠、手镯、觿、老料随形、佩饰、挂件、随形山子、戒指、肾状随形、耳环、多宝串、饼状随形、水滴状随形、瘤状随形、观音、弥勒、佛像、平安扣、三通、瑞兽等。因像鸡油一样的黄色,备受人们喜爱。这并不奇怪,因为中国人对这一色彩的追求可以追溯到明代。来看一段资料"成化时期黄釉瓷器烧造也是相当成功,釉色呈鸡油色的娇嫩,人们称之为'娇黄',也有人称之为'浇黄',就是像浇洒到鸡身上的鸡油黄一样,达到了在色彩烧造的顶峰,弘治时期也是达到了相当高的水平,在釉色上呈色稳定,娇艳的黄色,色泽凝重,给人以震撼"(姚江波,2010)。由此可见,中国人与鸡油黄色的情结非常具有渊源。在这种背景之下,从数量上看,鸡油黄蜜蜡在造型种类上十分丰富,几乎囊括了各种造型,是目前市场上销售蜜蜡制品的主流色彩。但

仿蜜蜡执壶(三维复原色彩图)

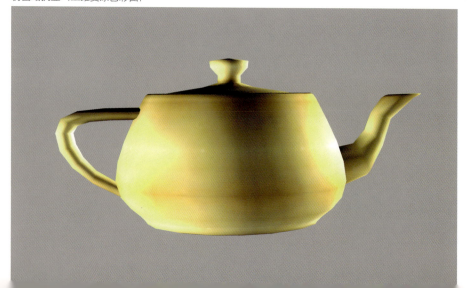

蜜蜡执壶（三维复原色彩图）

从时代上看，鸡油黄蜜蜡老蜡很少见，以当代为主。从大小上看，鸡油黄蜜蜡在大小上的特征比较复杂，大小不一，比老蜡普遍要大，但是比浅黄色通常要小。但这种特征是整体性的对比，并不具备个体之间类比，我们在鉴定时应注意分辨。从规整上看，鸡油黄色的蜜蜡在造型规整程度上比较好。因为鸡油黄色的蜜蜡已经属于中高档的蜜蜡，所以在制作上多数都是比较讲究，在造型上出现问题的很少见，筒珠圆润、规整，毫无缺陷。从相似性上看，鸡油黄蜜蜡在器物造型上相似性较强，相互模仿，互相借鉴之风在当代盛行，选择造型隽永、鹤立鸡群者，收藏价值自然就高。从功能上看，鸡油黄蜜蜡造型与功能的关系很明确，以陈设装饰为显著特征，结合实用的功能，如手串、项链等较为典型。从写实性上看，鸡油黄蜜蜡在器物造型上较具写实性，如龙、生肖、秋叶、茄子等一看便知，偶见有写意的造型。

蜜蜡随形摆件

蜜蜡摆件

蜜蜡随形摆件

五、橘黄蜜蜡

橘黄色蜜蜡常见，器物造型比较丰富，手串、吊坠、单珠、手镯、随形摆件、佩饰、挂件、随形山子、多宝串、饼状随形、水滴状随形、肾状随形、瘤状随形、平安扣、三通、瑞兽等都有。由此可见，橘黄色蜜蜡在造型上的确是比较丰富。但是从出现的频率上看，手串、吊坠、挂件、佩饰为常见，手镯也有见，但数量不是很多。总之，在出现的频率上给人的感觉是戒指、耳环等镶嵌类出现的少一些。另外，观音、佛像等也比较少见，这使我们想到了这种蜜蜡在色彩上虽然很像老蜡，但毕竟不是老蜡，并不是特别名贵，所以也较少镶嵌在较为名贵的戒指和耳环之上。从时代上看，橘黄色蜜蜡在古代也很常见，从遗留下来的蜜蜡看也比较常见，但是单色呈现的不多，多是作为受沁色彩的一部分出现。对橘黄色蜜蜡大规模的使用主要是在当代，目前在市场上就比较常见，价位还不是很高，应该具有较强的升值潜力。从大小上看，橘黄色蜜蜡在大小上的特征比较复杂，虽然说大器、小器都有见，但是终归以串珠、挂件类小件为多，大器还是少见。这与其原料的大小，以及材料的珍贵性有着密切的关联。

从规整上看,橘黄色的蜜蜡在造型规整程度上比较好,虽然不是一种十分名贵的蜜蜡,但是在工艺上也是特别讲究,造型圆度规整,弧度自然,很少出现败笔。只是偶见有不规整者,这可能与较低的价格有关。多年以前,有的一个手镯批发才几十块钱,所以它用在造型上的成本极为有限。但这种资源还是相当的稀缺,因此有的时候此类不容易变现的物品,常常出现矛盾的情况,就是成品的价格反而不如原料的价格,而此时也是我们出手之时。因为这种情况不会长久,很快市场便会有反应。从相似性上看,橘黄色蜜蜡在器物造型上相似性较强,机器制作,模仿之风较盛。但近些年来此风有所止,原因是与其猛增的价格有关,人们开始重视其造型的设计、创新。从功能上看,橘黄色蜜蜡造型与功能的关系很明确,以陈设装饰为显著特征。从写实性上看,橘黄色蜜蜡在器物造型上较具写实性,器物造型一看便知,艺术性有限。这与橘黄色蜜蜡被人们认识的时间过短有关,相信随着时间的推移,橘黄色蜜蜡在造型上的写意效果必然会有一个大的飞跃。

蜜蜡随形摆件

蜜蜡随形摆件

蜜蜡随形摆件

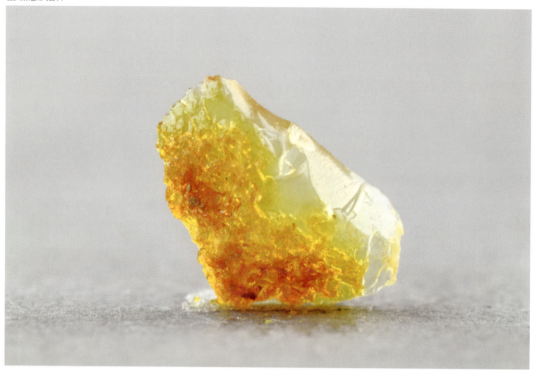

蜜蜡随形摆件

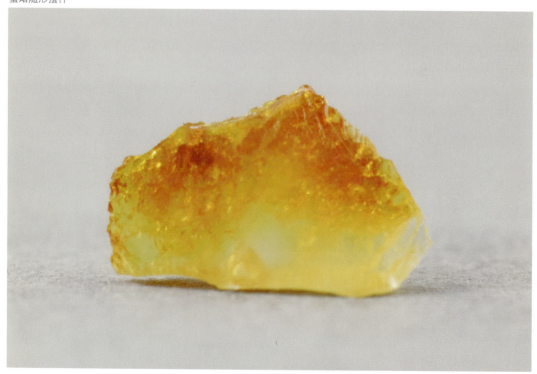

第二节 形制鉴定

蜜蜡串珠

一、珠 形

蜜蜡当中球形的造型最为常见，大多数珠子的形状都是球形。人们将蜜蜡磨制成大小不一的珠子，中间打孔后用绳子穿起来，成为串珠、手链、项链等装饰品，早在新石器时代就有这样的穿系。但是，球形的珠子由于技术含量比较高，直到汉代才大量的出现，之前的珠子大多不是球形的，而是以算珠等形状为常见。球形圆润、漂亮，受到很多人的喜爱，所以无论是商周秦汉、六朝隋唐辽金、宋元明清等各个时期都受到人们的青睐。从数量上看，球形的造型是随着时代发展而发展的，简单地说可能是随着技

蜜蜡珠（三维复原色彩图）

蜜蜡单珠、唐三彩碟组合（三维复原色彩图）

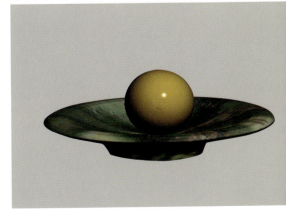

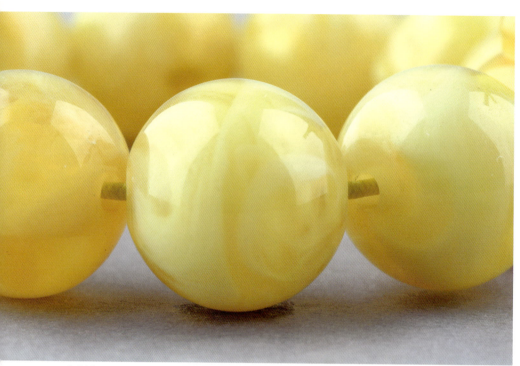

仿蜜蜡手串

术的进步而发展的,而且这一趋势非常的明显。当代的技术最为高超,蜜蜡球形的造型也发展至鼎盛。当代生产了比以往任何一个时代都多的珠子,生产了任何一个时代都无法比拟的大量的串珠、手链、项链、挂件等。这些主要都是用球形的珠子串联起来的,或者是当中重要的组件。由此可见,人们对于圆球形的偏爱。当然,这与当代科技有关,因为在当代基本上都是用机器磨圆珠子的球体,非常简单,产量也大,一天生产的量也许就是过去一个时代的生产量,可见人工和机器的差距。当代珠子有一个缺陷,就是千篇一律都一样。这和尺寸大小没有关系,指的是其造型一致。这样有一个缺点就是我们不能够看到工匠在打磨珠子时的所思所想,失去了一些历史信息;但优点是相当漂亮,造型规整,适合于穿系。当然有些人不喜欢这样的珠子,从而进行手工制作,但在今天这样一个时代里是否有必要用手工将蜜蜡磨成球形,是一个值得讨论的问题。不过目前市场上的情况就是这样,我们在鉴定时应注意分辨。

第二节 形制鉴定 **81**

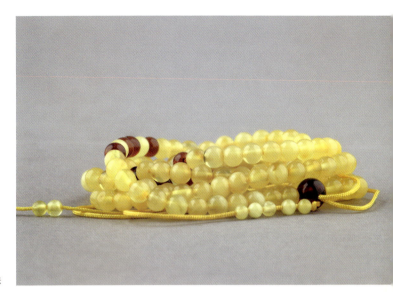

蜜蜡串珠

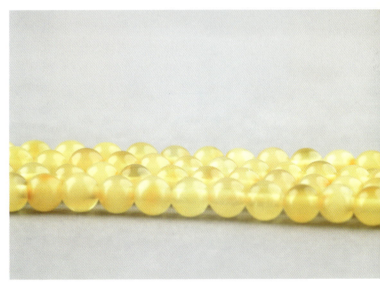

蜜蜡串珠

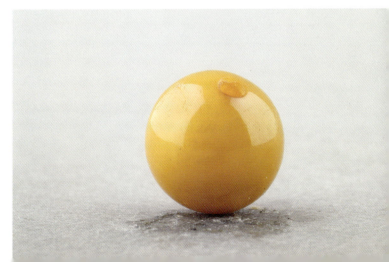

仿老蜡珠

二、圆柱形

圆柱形的造型在蜜蜡中常见。圆柱体是立方体的水平旋转，这种造型在蜜蜡之上经常被应用到各种器物之上，与其单独成形最接近的是筒珠。筒珠的造型比较丰富，无论是中国古代还是当代都常见，可以作为挂件单独存在，也可以作为组件，制作成手串等。从具体造型上看，筒珠的造型实际上并不是几何意义上的概念，而只是视觉上的概念，以视觉为判断标准。筒珠的圆柱体基本上都比较规整，不规整的情况是顶面和底面的边缘往往有弧度，这是其与圆柱体不相符合的地方。但这项设计显然在美观上漂亮了许多。从时代上看，圆柱形的造型在商周秦汉时代有见，但还没有形成流行的趋势；而在六朝隋唐辽金时期圆柱形的造型经常有见；宋元明清时期圆柱形造型增加许多，可以说是经常看到。当代圆柱形的蜜蜡造型也常见，基本上延续传统，主要是串珠，各种各样的手链为多见，实际上和现在的筒珠可以画上等号。当代蜜蜡圆柱形的造型数量最多，筒珠的数量达历史新高。从具体的造型上看，蜜蜡造型规整，圆度规整，具有相当的视觉震撼力。这一点我们在鉴定时应注意分辨。

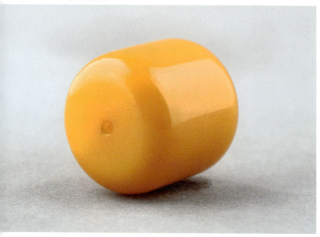

仿蜜蜡筒珠

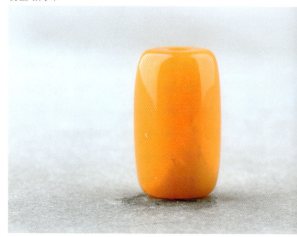

仿蜜蜡筒珠

第二节 形制鉴定 **83**

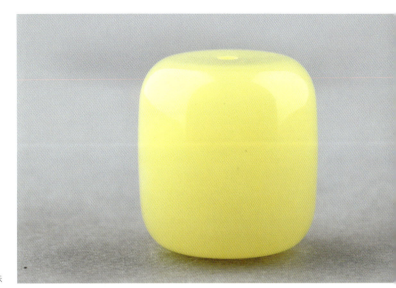

仿鸡油黄筒珠

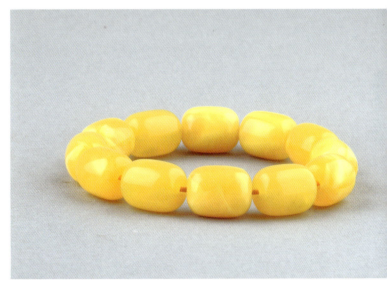

仿蜜蜡筒珠手串

仿蜜蜡筒珠

仿蜜蜡筒珠

三、蟠桃形

蟠桃形的蜜蜡造型有见。蟠桃是一种水果,是神话故事中吃一个可以增加寿命几百年的仙桃,在历代的艺术作品和文学作品中多有出现。在神话作品《西游记》中,孙悟空专管蟠桃园,土地神介绍蟠桃园有三千六百株桃树,有的果实三千年一熟,人吃了增加寿命;有的果实是六千年一熟,人吃了与天地同寿,可以长生不老。由此可见,人们对于蟠桃的美好憧憬。所以,蟠桃的形象常常出现在墓葬当中,在蜜蜡的造型上出现也是再正常不过的事情了。但从蟠桃在蜜蜡上的应用来看,数量不是很多,有的也是作为组件存在,或是圆雕的局部题材,从而实现衬托造型,或者材质珍贵性的素材,多数构思极为巧妙,巧夺天工。当代蜜蜡当中也是时常有见,鉴定时我们应注意分辨。

四、长方形

长方形的蜜蜡造型历代都比较常见。如牌、吊坠、銙、戒面、印章、长方形管等都有长方形的造型。但长方形只是一种形制，而不是一种具体的造型，实际上无论是牌饰还是戒面等，对于蜜蜡而言，实际上更为贴切的造型是长方体。所谓的长方体，是由六个长方形围成的立体空间，无论牌多么薄，显然长方体的空间都是存在的，这一点我们在鉴定时应注意分辨。从具体造型上看，所谓长方形的造型实际上多数不是几何意义上的，而是视觉上的，如牌饰的造型，通常情况下四个角都不是 90°，而是有弧度的，不同的牌饰，弧度不同。还有如戒面虽然长方形比较规整，但是正面多是有弧度的。另外，印章和长方体管的造型基本都是这样，没有完全的长方形，长方形只是视觉意义上的，但这种造型主要是以古代为主。当代长方形的造型有见这种情况，因为如果电脑进行操作切割的话，长方体的造型是准确的。但这只是理论上的，通常情况下都有些弧度，这样有利于美观。从时代上看，商周秦汉蜜蜡之上长方体者有见，但主要以串饰的组件为主，也有见印章和少量的牌饰等。六朝隋唐辽金蜜蜡在长方形的造型上延续传统，只是在长方形所应用的题材上有所增加，如印章、管、项链、手链、挂件等上面都常见长方体的造型。宋元明清蜜蜡上长方形的造型更为常见，各种造型都有见，但主要以各种牌饰数量为多见，另外，戒指等也都比较常见。民国时期在长方体的造型上基本延续明清，没有过多的创新。当代蜜蜡长方形的造型十分常见，印章、管、项链、手链、挂件、戒面等都有见，几乎囊括了历史上所有出现过的器物造型，而且从数量上看，也是非常多，达到历史之最。这与长方体简洁、大方，可以比较直观地表现蜜蜡的特征有关。鉴定时我们应注意分辨。

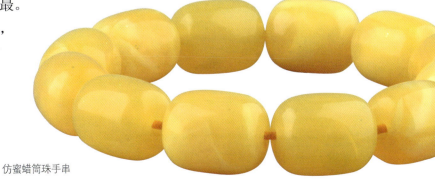

仿蜜蜡筒珠手串

蜜蜡随形摆件

蜜蜡摆件

蜜蜡随形摆件

蜜蜡摆件

五、扁圆形

蜜蜡扁圆形的造型十分常见，涉及的器物也比较丰富，如鼻烟壶、串珠、单珠、吊坠、耳坠、挂件、戒面、随形摆件等都常见。就其造型本身而言，扁圆形珠子其实是由圆形演变而来，就是较薄的圆形，当然理论上是这样的，但是从蜜蜡珠子的造型上来看却并不是几何意义上的，而是视觉上的概念。如鼻烟壶常见有扁圆形的造型，但多数是腹部扁圆形。实际上从清代蜜蜡鼻烟壶来看，腹部圆的成分更大一些，有的还略有些上鼓，串珠、挂件等基本上都是这样的特征，这是从概念上看是这样。

从数量上看，扁圆形的造型在具体的器物造型当中并不是很常见，如鼻烟壶的造型在鼻烟壶中数量并不常见，基本上处于偶见的状态。从规整程度上看，扁圆形的蜜蜡造型在规整程度上大多是圆度规整，非常的漂亮。

从时代上看，商周秦汉蜜蜡当中扁圆形的造型有见，但主要以串珠类为主，造型规整，弧度圆润，不过总量很少。六朝隋唐辽金蜜蜡扁圆形的造型有见，但总量基本上也都很少，造型较为规整。宋元明清蜜蜡扁圆形的造型有见，弧度圆润，造型规整，数量逐渐增加；到明清时期已经是比较常见。民国时期扁圆形的蜜蜡在数量上有所增加，如戒面有许多就是扁圆形的，但特征基本上与清代相当，没有太大的变化。当代蜜蜡在扁圆形的造型上可谓是达到了历史之最，一是数量上最多；二是造型细微的变化比较丰富；三是所涉及的器物造型丰富。当代蜜蜡扁圆形造型大多数造型规整、隽永，既照顾到了传统，又在现代化的机器雕刻背景下，扁圆形相当规整，有的几乎是几何意义上的扁圆形，这也是当代扁圆形造型同古代的根本区别。当然也有纯手工的扁圆形蜜蜡造型，但数量很少见，鉴定时应注意分辨。

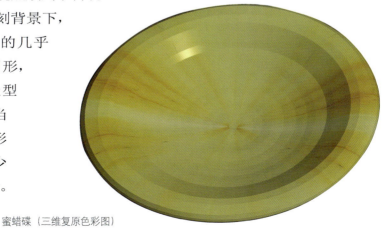

蜜蜡碟（三维复原色彩图）

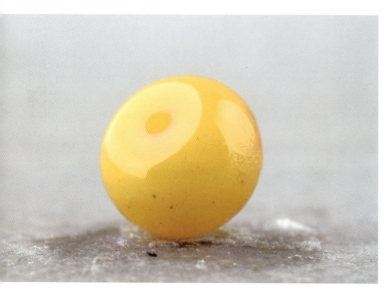

老蜡珠

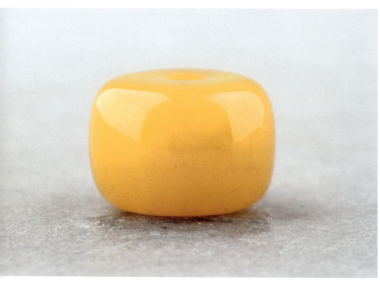

仿蜜蜡算珠

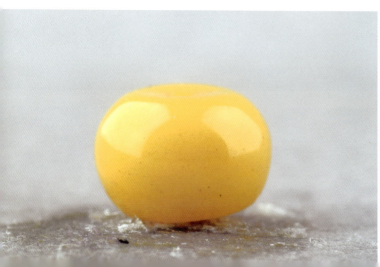

老蜡珠

第二节 形制鉴定

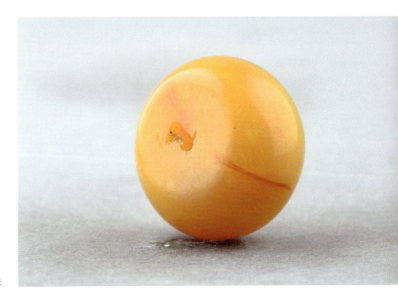

仿蜜蜡算珠

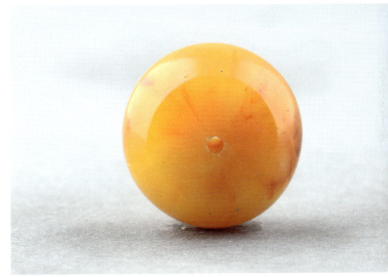

仿蜜蜡算珠

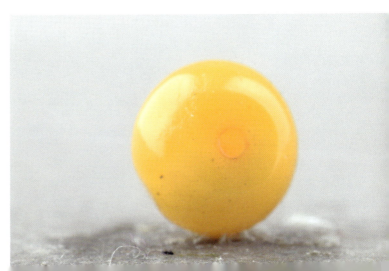

老蜡珠

蜜蜡摆件

六、鸡心形

鸡心形的蜜蜡造型常见。《诗经·小雅》："日月阳止，女心伤止。"鸡心形是爱情的象征，同时也是至深感情的象征，而这与蜜蜡的材质和功能有着异曲同工之妙。所以，鸡心形的造型用在蜜蜡之上也是再常见不过了。鸡心形可以说在很早以前就被人们反复琢磨。在汉代的玉器之上就有很多鸡心形的造型，而我们知道，汉代玉器盛行的是广义的概念，将蜜蜡包含在了玉里面。六朝隋唐辽金蜜蜡鸡心形的造型也有见，在诸多方面基本上延续汉代。宋元明清蜜蜡鸡心形的造型也是比较常见，象征爱情的功能较强，特别是明清时期更是这样，青年男女会互送一些鸡心形的礼物。看来在那个封建的年代，纯真的感情依然浪漫，所以这也从一定程度上推高了鸡心形在蜜蜡上的应用。民国时期基本上是延续了传统，创新比较少见。当代蜜蜡鸡心形造型十分常见，但从数量上来看，应该是历史上最为流行的一个时期。从器物造型上看，鸡心形造型常常被应用到了各种具体的器物造型之上，如吊坠之上就特别常见，以机器琢磨为主，弧度自然，造型隽永，精美绝伦。部分使用手工雕琢与机雕相结合的工艺，不过这基本上属于非常高档的艺术品，多为工艺美术大师所雕刻，数量很少见，我们在鉴定时应注意分辨。

仿蜜蜡筒珠手串

七、椭圆形

　　椭圆形的造型在蜜蜡中最为常见。从椭圆造型本身来看，非常适合人们的视觉审美习惯，这一点毋庸置疑，弧线走椭圆，古人很早就使用椭圆形的造型。商周秦汉蜜蜡就有椭圆形的造型。六朝隋唐辽金蜜蜡常见，椭圆形的造型比较规整，弧度圆润，主要多以管等为常见，串珠也有见。宋元明清蜜蜡在造型上椭圆形也是比较常见，特别是明清时期椭圆形的蜜蜡常见，如吊坠等成为主流。民国时期椭圆形的蜜蜡也是比较常见，基本上为传统的延续。椭圆形的蜜蜡真正繁荣是在当代，当代蜜蜡当中椭圆形的造型最多，所涉及的器物造型日益扩大化，如戒指、耳钉、串珠、手链、项链、挂件、吊坠等都常见，而且数量特别多，比任何一个时代出现的频率都要高。从做工上看，当代蜜蜡椭圆形的造型多数为机制，程式化的制作，同一批产品在造型上几乎是相同的，创新性受到一定的限制，但有一些十分精致的作品，基本上为工艺美术大师作品，纯手工制作，工艺精湛，造型隽永，几无缺陷，精美绝伦。鉴定时应注意分辨。

仿鸡油黄筒珠

仿蜜蜡筒珠

八、龟 形

龟的造型在古代常见。《山海经》记载有"旋龟，其状如龟而鸟首虺尾"。《本草纲目》称"龟、鹿皆灵而有寿。龟首常藏向腹，能通任脉，故取其甲以补心、补肾、补血，皆以养阴也"。由此可见，龟在古代是一种灵物，而且是与寿命有关的一种神兽。新石器时代红山文化玉器之中就有龟的形象。商代将文字刻在龟甲之上，这样来推测商周秦汉时期应该存在蜜蜡制品的龟，但应该是很少见。而秦汉时代龟的造型在蜜蜡上的应用就较为普遍了，如印章上的龟形钮，龟的形象还是比较写实，但写意的倾向已经有所显现。六朝隋唐辽金蜜蜡基本上延续了这一传统，直接描述龟的造型的比较少。宋元明清蜜蜡基本也是这样，龟的造型有所延伸，如龙龟、兽龟等的造型都比较常见。民国时期的龟形蜜蜡比较常见，以吊坠为多见。当代蜜蜡制品当中龟的造型也是比较常见，造型还是以写实为主，很容易就可以看出来是龟，造型隽永，雕刻凝练，总之是各种龟的造型都有见，具有吉祥的寓意。鉴定时应注意分辨。

九、方 形

方形在蜜蜡上的应用比较广泛，中国"天圆地方"的概念自古就有，如新石器时代的玉琮就是这种观念的代表性器物，玉琮外方内圆，外方代表的是大地，大地一层层的上升，最终到达圆孔的尽头天庭，由此可见，方形对于中国人有着特殊的意义。方形的蜜蜡制品自古就有，如玺印、戒面、吊坠、方珠、管等都比较常见，但

蜜蜡随形摆件

蜜蜡随形摆件

蜜蜡随形摆件

蜜蜡随形摆件

蜜蜡随形摆件

纯正的正方形比较少见。所谓蜜蜡的方形显然是视觉意义上的,并不是几何意义上的方形。当然,蜜蜡方形的造型还有许多,如蜜蜡吊坠,通常是中空的方珠,看起来非常漂亮;戒面也常见方形的,但正方形的造型的确不是太多。纯正的方形主要还是以印章为多见,这一点从古到今几乎没有太大的改变。总之,蜜蜡方形的造型和琥珀基本相似。从时代上看,商周秦汉时期蜜蜡方形者有见,但主要以方管为多见,不过数量很少。六朝隋唐辽金方形蜜蜡的数量有所增加,但基本上还是限制在玺印等器物。宋元明清时期,在方形造型上有所发展,器物造型扩大化的趋势明显,戒面、耳钉、诸多方形镶嵌等造型都出现了。民国时期基本延续前代。当代蜜蜡在方形造型上同样取得了辉煌的成就,主要以印章为主,方形戒面、耳钉、诸多方形镶嵌都有见。由此可见,方形这一古老的造型从商周秦汉发展至今日,终于在当代达到了鼎盛。

十、环 形

环形通常就是人们所说的圆环。圆环的造型本质上很简单,就是大圆盘挖去小圆盘所剩下的部分。环形本身可以成型,蜜蜡环也常见,但是真正环形的造型所见还不是很多,主要应该是手镯的造型比较流行,特别是在当代蜜蜡当中,手镯的造型十分常见,而且数量相当丰富。实际上,类似环的造型很多,最有名的应该是蜜蜡璧。这种璧形的造型在玉器之上经常见到,在蜜蜡上的应用虽然是有见,但是数量不是很多。另外,平安扣也是最为常见的一种造型,这种造型在当代几乎是一种普及化的蜜蜡造型,出现的频率非常的频繁。戒指、耳环等也都是非常的常见,都是大家耳熟能详的造型。从具体造型上看,环形造型制作相当精致,基本上是精益求精,做工精湛之器,正圆环形,几无缺陷。特别是古代的环形蜜蜡更令人称道,因为环形蜜蜡手工制作相当的费工费力,与当代的机械取环的造型相比,古代相当的不容易。环形正圆,圆度规整,几无缺陷。更加具有价值。我们这个时代环形造型数量非常的多,当然与取环比较轻松有关,但是数量往往也可以说明一个问题,就是人们对于环形的喜爱达到了偏执的程度,这是以往任何时代都不能比拟的。但缺点是环的形状一样,失去了创作的过程,不能够从环上看出工匠的所思所想,这是当代环不及古环形造型的一个缺陷。另外,从大小上看,对于蜜蜡这一特殊的造型而言,蜜蜡环的造型越大,通

蜜蜡镯(三维复原色彩图)

老蜡镯子（三维复原色彩图）

常情况下越贵重。因为蜜蜡原料的大小有限，大的环形造型不容易取。当然，这只是从理论上讲，实际上影响其贵重程度的因素还有很多，如料的优良程度、产地、出自名家之手、时代等因素都能影响到其贵重程度，这一点与琥珀、玉石类基本都差不多。从时代上看，商周秦汉蜜蜡环形的造型主要以玉璧等为主，玉环也有见，但数量不是很多。六朝隋唐辽金蜜蜡在数量上有所增加，特别是环的数量有所增加，但整体来看基本上是延续了前代的诸多特征，没有太大的革新。宋元明清蜜蜡在环形造型上明显增多，璧的数量下降，环的数量依然强劲，手镯在数量上增加到了一个非常令人羡慕的程度，戒指的数量也有增加，与前代相比出现了一个极为繁荣的局面。民国时期基本上延续明清，改变不是很大。当代蜜蜡环形的造型真正是达到了一个鼎盛时期，平安扣、镯子、环、戒指、扳指等都出现了一个最为鼎盛的局面，在数量上也达到了一个新高。

仿蜜蜡手串

十一、橄榄形

橄榄的原产地在中国，是一种美味的水果，为中国人所熟悉，因此橄榄的造型在蜜蜡当中也是经常有见。从形制上看，橄榄非常有型，两头小，中间大。橄榄形的蜜蜡造型在汉代已经有见，六朝隋唐辽金时期也有见，宋元明清时期更是常见，乃至当代更是十分常见。由此可见，橄榄的造型在蜜蜡上的确是相当流行。蜜蜡之所以用如此大的热情来描述橄榄，显然是因为橄榄为人们所熟悉。抓住了橄榄的造型，实际上就是可以和所有人共鸣，这样其生产的产品铆定了所有的人群。从琢工上看，橄榄形的蜜蜡造型相当珍贵，这主要与蜜蜡是一种极为珍贵的宝石原料有关，在琢磨上极尽心力，精工细琢，几无缺陷。从具体造型上看，常见戒面、橄榄珠、耳钉、吊坠等。戒面的造型实际上多以镶嵌为主，将橄榄的造型镶嵌在戒指之上，成为橄榄形的戒面。橄榄珠通常情况下比较大，造型隽永，雕刻凝练，分外美丽。吊坠的造型也是比较常见，通常也是制作成橄榄的造型，不过吊坠多是不太规整。由此可见，其实蜜蜡所谓橄榄形的造型其实都不是几何意义上的橄榄形，与真正橄榄的造型有区别，看来多数属于视觉意义上的橄榄造型，以视觉为判断标准，这一点我们在鉴定时应注意分辨。

十二、高度特征

蜜蜡在高度特征上比较明确，以小为显著特征。如汉代蜜蜡零点几厘米到1厘米的高度常见，主要以早期印章和串珠为主，可见蜜蜡在汉代的珍贵程度，同时我们也可以感受到蜜蜡原料的奇缺程度。所以，高度对于蜜蜡鉴定而言十分重要，由高度特征不仅可以知道历史信息，最重要的是可以知道某一个历史时期之内蜜蜡在造型上大致的高度范畴，给鉴定提供一个大致高度概率参考，这是其最主要的功能。商周秦汉蜜蜡在高度特征上比较明确，商周早期由于发掘出土很少，应该也是在1厘米左右，可见是比较小；汉代蜜蜡在高度特征上是一个递进的过程。六朝隋唐辽金蜜蜡在高度特征上多在1～2厘米，由此可见，六朝隋唐辽金蜜蜡在体积上与汉代相比略有增长，但本质上并没有太大的改观，因为即使1～2厘米依然是小器。宋元明清蜜蜡在高度特征上有大幅度增加，有的吊坠的达到4厘米左右，鼻烟壶高度达到6.5厘米左右，一些山子的高度而达到30多厘米，由此可见，高度已经高出了数倍，这是一种高度上的飞跃。民国蜜蜡在高度上基本延续明清。当代蜜蜡在高度特征上则是大小兼备，各种各样的高度特征都有。小的零点几厘米，如戒面的高度，一颗珠子的高度等；但是总的趋势是比中国历史上蜜蜡高度要高得多，这一点我们在鉴定时应注意分辨。特别是当代蜜蜡高度在10厘米以上者比比皆是，几十厘米的大器时常有见，而且数量特别多，这在古代是不可思议的事情，这主要与蜜蜡的原石增多有关。蜜蜡的来源渠道较广，大量的波罗的海沿岸国家的蜜蜡被进口到中国，缅甸的蜜蜡也大量涌入，这样就为大型蜜蜡雕件的普及奠定了基础。由此可见，从整个蜜蜡史的角度来看，蜜蜡的高度当代显然是达到了历史之最。这种辩证的关系我们在鉴定时应能理解。

蜜蜡如意

蜜蜡串珠

宋油滴釉瓷碟蜜蜡如意（三维复原色彩图）

蜜蜡碟（三维复原色彩图）

蜜蜡摆件

蜜蜡随形摆件

蜜蜡随形摆件

十三、长 度

　　古代蜜蜡在长度特征上比较明确，整体长度特征不是很理想，仍然属于小器的范畴。这与古代蜜蜡原料的奇缺程度有关，不同时代在长度特征上不同，主要取决于蜜蜡原料的稀缺程度。长度鉴定对于蜜蜡而言十分重要，它可以知道某一个历史时期之内蜜蜡在造型上的大致长度，给鉴定提供一个可参考的概率。早期蜜蜡在长度上很小，如先秦的蜜蜡由于出土数量相当少，我们几乎无法勾勒出一个大致的概率范围，这说明先秦的蜜蜡如同我们当代的钻石一样珍贵。汉代的蜜蜡在长度特征上往往只有1～2厘米，或者说这种长度很常见，虽然多是一些印章的造型，但是由此我们也可以窥视到汉代蜜蜡在长度特征上数值是多么的小。六朝隋唐辽金蜜蜡的长度特征基本延续前代，在长度特征上比原来有所进步，但只是微小的变化。宋元明清蜜蜡在长度特征上特征明确，宋元时期还是在缓慢地改变，但是从明清时期的墓葬当中出土的蜜蜡，或者是传世的蜜蜡制品来看，5～6厘米，10厘米以上的情况都是比较常见。但不同的器物造型在长度上不同，花片的长度达到6厘米左右，墨床的长度10厘米左右，手镯的直径可以达到8厘米左右等，当然这只

是较为流行的器物在这个区间之内，一些特殊的长度也是时常有见。民国蜜蜡在长度特征上基本延续明清，比较固守传统。当代蜜蜡在长度特征上可以

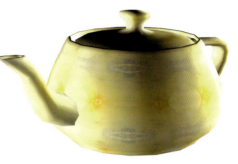

蜜蜡执壶（三维复原色彩图）

说是集大成，各种各样的长度特征都有见，长度的数值进一步增大。如戒面的长度通常是1.5～2.0厘米，山子和摆件通常都是比较大，总之在长度数值上可以达到历史之最，当代蜜蜡组成了浩荡的、不同尺寸的造型群。从数量上看，各种长度特征的蜜蜡制品都是比较常见，出现的频率比较高。鉴定时应注意分辨。

蜜蜡摆件

蜜蜡如意

第二节 形制鉴定 **101**

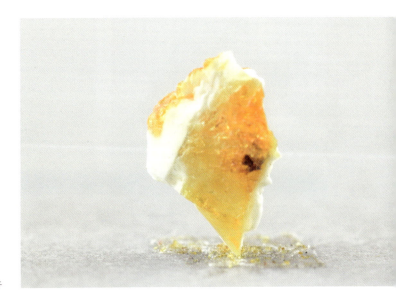

蜜蜡随形摆件

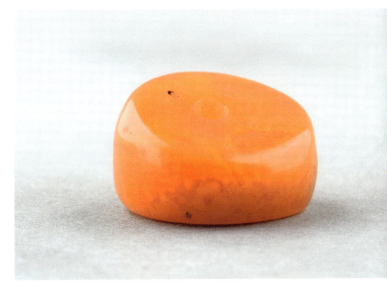

仿老蜡珠

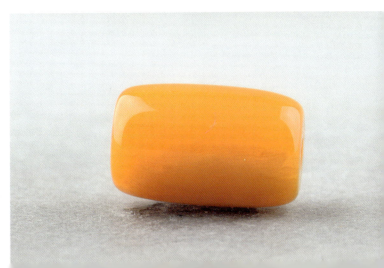

仿蜜蜡筒珠

蜜蜡随形摆件

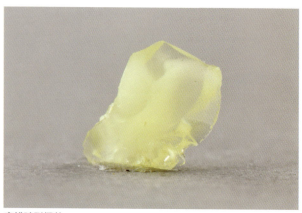
蜜蜡随形摆件

十四、宽　度

　　蜜蜡在宽度特征上比较明确，数值总的来看比较窄。从时代上看，商周秦汉蜜蜡在宽度上数值很小，多数宽度只有零点几到 1 厘米这样。六朝隋唐辽金蜜蜡在宽度特征上基本延续前代，并没有太大的改变，从墓葬发掘的情况来看，只是略大一些而已。宋元明清蜜蜡在宽度特征上比较明确，器物造型宽度逐渐增大，如佛手的宽度多在 8 厘米左右，珠子的宽度可以达到 3 厘米，这样的宽度特征可以说比以往大了许多，可见蜜蜡饰件的宽度显然是有所增加，而且增加的幅度很大，特别是明清时期幅度最大。原因可能是多方面的，但主要原因应该与蜜蜡进口料的增多有关。民国蜜蜡在宽度上基本延续了明清时期，没有多大变化。当代蜜蜡在宽度特征上较之明清时期有所增加，但增加的幅度不大，而且是大小兼备，各种各样的宽度特征都有见，开启了造型真正多样化的局面，在历史上，宽度特征应该是达到了最好的一个时期。如戒面较大，如山子、摆件、人物等都有相当的宽度特征。鉴定时应注意分辨。

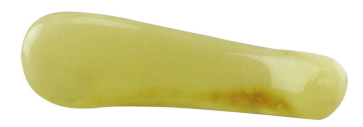
蜜蜡如意

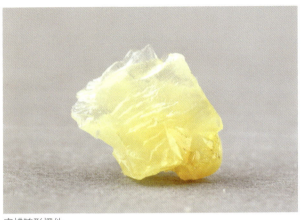
蜜蜡随形摆件

蜜蜡随形摆件

十五、厚 度

蜜蜡在厚度特征上比较明确，早期以薄为主，厚重少见，为辅助。商周秦汉蜜蜡就是这样，如印章的边长不到1厘米，显然说明其厚度相当的薄。六朝隋唐辽金蜜蜡在厚度特征基本上延续传统，厚度特征数值很小，但逐渐是在增大，是一个渐进的过程。宋元明清蜜蜡在厚度上特征明确，虽然还是延续传统，但是在厚度上略微增加一些，主要是围绕着造型略微有所增加。民国蜜蜡在厚度特征上增加并不明显，只是惯性地延续着传统。当代蜜蜡在厚度特征上变化比较明显，厚度明显增加。特别是有些圆雕的作品，如把件等非常的厚，也就是手刚刚能够把住。当代蜜蜡在厚度上显然是过去任何一个时代都不可比拟的，蜜蜡不再只是选择片雕的作品为主，而是在造型的涉及上不再考虑原料是否有，只是设计出美的作品就可以了，因此当代蜜蜡制品看起来饱满、圆润，非常漂亮。当然这与当代蜜蜡原料增加有关系，商人们不必过于考虑原料的节省问题，这样在厚度上就比较自如了，以造型为主，这一点我们在鉴定时应注意分辨。

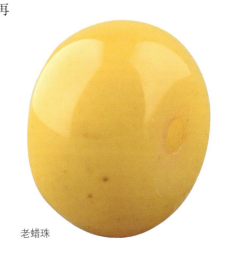
老蜡珠

蜜蜡随形摆件

蜜蜡摆件

蜜蜡如意

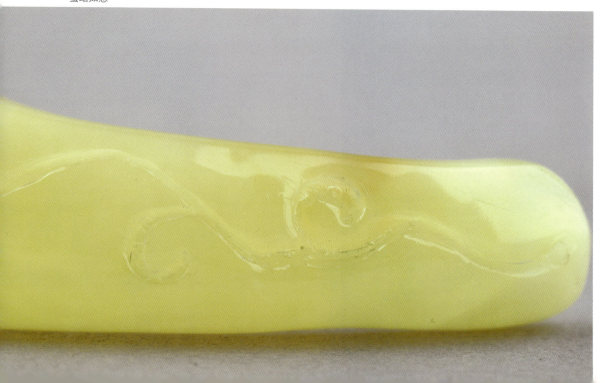

蜜蜡随形摆件

蜜蜡随形摆件

蜜蜡串珠

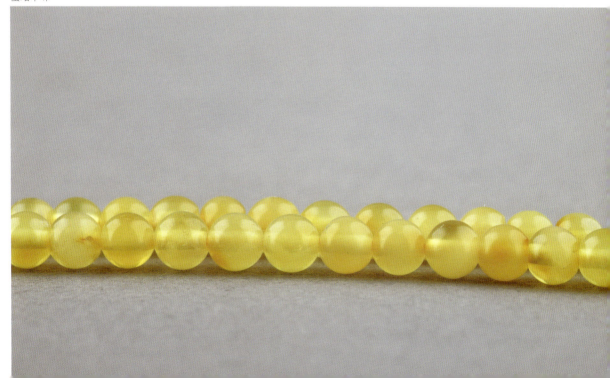

十六、山子

山子作为一种艺术形式，早在新石器时代应该就有见。但早期的山子并不像今天那样的流行，形态也介于山子和其他器皿之间，很难确定山子的造型，这种情况直至宋元时期。当然唐代也有见山子的造型，不过蜜蜡山子的造型却是很少见到。蜜蜡山子主要是以明清时期为多见，多是一些摆件，一般都有底座，也有的没有底座，层峦叠嶂，山峰斜起，泉水叮咚，山上树木丛生，小桥流水，成片的竹林，仙鹤、麋鹿等小动物应有尽有。蜜蜡山子的造型或者纹饰多是以小见大。从蜡质上看，隋唐宋元时期的蜜蜡山子质地优良、温润，手感滑顺，莹润如脂，细腻、无杂质。都采用较好的蜜蜡料，块相当大，多是整块雕琢，偶见有个别小件蜜蜡质地不是太好，主要是有的肯定不是软蜜蜡制品，但总的来看较好。总之，明清时期

蜜蜡山子摆件

蜜蜡山子摆件

蜜蜡山子摆件

蜜蜡山子摆件

是蜜蜡山子发展的鼎盛时期，蜜蜡山子作品发展很快，种类更为繁多，寓意深刻。民国时期山子的造型基本上没有太大改变，延续明清山子的造型及纹饰特征，革新并不明显，精品力作也少见。当代蜜蜡由于原料进口比较多，蜜蜡原料的因素基本上解决掉了，起码是暂时性地解决了一些，所以蜜蜡山子达到了鼎盛，产生了无与伦比的山子造型，是蜜蜡的一个亮点。下面我们具体来看一下当代蜜蜡山子的造型。

（1）从造型上鉴定：当代蜜蜡山子造型在延续传统的基础之上有所增加，其造型主要以随形雕件为主。当然随形并不是无形，常见的造型主要有荔枝形、长方形、扁方形等，其数量之多是任何一个时代都不可比拟的。由此可见，蜜蜡山子造型的确是增加了。随形山子的造型并无定式，各种各样的造型都会出现，有的横着放，有的竖着放，耐人寻味，给人以异样的美感。当然，山子造型之所以在当代如此的盛行，显然也与蜜蜡原料依然珍贵分不开。对于一些大的蜜蜡原料，很多人都舍不得将其切割制作雕件，而是将其制作成山子等摆件，这样既利用了雕件，又保护了如此大块的蜜蜡原石。

蜜蜡山子摆件

蜜蜡山子摆件

蜜蜡山子摆件

蜜蜡山子摆件

蜜蜡山子摆件

蜜蜡山子摆件

（2）从创作手法上鉴定：当代蜜蜡山子在创作手法上特征明确，依然延续传统，主要以"以小见大"为显著特征。无论是人工雕琢的蜜蜡山子摆件，还是未经过修饰的随形摆件都有这个特点，通过微缩版的比例缩小，将山林、树木、亭台楼阁、人物故事等搬上蜜蜡山子，这一点与隋唐宋元时期的蜜蜡山子不谋而合，看来应该是传统的延续。用纹饰或者是其他的雕琢手法将一块块的蜜蜡料雕琢成为"天地宽广"的山林世界，山路曲径幽深。实际上这是以小见大的创作手法，因为它的载体是小的，但却要反映大世界，所以蜜蜡山子在这一点上没有选择的余地，基本上都是这样一个特点。对于没有雕琢纹饰的蜜蜡随形摆件，多是选择一些有皱折的，造型异样者为上，因为这些山子可以给人以无限想象的空间，而如果是抛光很好，几乎没有任何缺陷的原石，可能也就不能作为山子来使用了，因为它没有内涵。这显然也是一种"以小见大"的艺术手法，鉴定时应注意分辨。

蜜蜡山子摆件

蜜蜡山子摆件

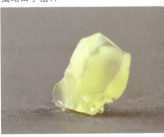
蜜蜡山子摆件

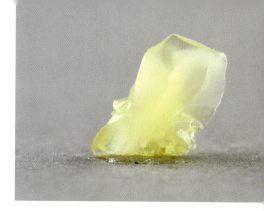

蜜蜡山子摆件

（3）从蜜蜡质地上鉴定：当代蜜蜡山子的蜜蜡质地温润，材质优良，多采用一些较大的蜜蜡料来进行雕琢。但从产地上看，多是来自波罗的海沿岸国家，特别是俄罗斯的比较多。从色彩上看，主要以黄色为基调，衍生出一些如棕黄、红棕、浅黄、橙黄、鸡油黄等色的蜜蜡。一般情况下，色彩都不是很纯正，多是一些渐变的色彩，但不影响其主流色彩的认定。纯正的蜜蜡色彩也有见，但数量很少，这与蜜蜡山子造型过大，纯正难度过高有关。鉴定时应注意分辨。

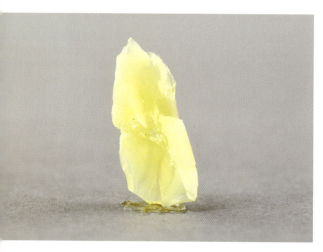

蜜蜡山子摆件

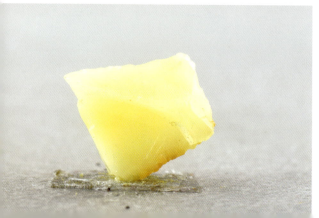

蜜蜡山子摆件

蜜蜡山子摆件

（4）从做工上鉴定：当代蜜蜡山子在做工上可以说是精益求精，力求无缺陷。这与蜜蜡材质的珍贵性有关，多数都是造型隽永、雕刻凝练的作品。从纹饰刻划上看，当代蜜蜡在纹饰上线条非常细腻、刚劲有力，十分流畅，在琢工上非常仔细，几乎很细小的地方都打磨到了，不留死角。局部镂空的方法也有见，局部浮雕、浅浮雕、透雕、立体、隐起等装饰手法都有见，有的时候是共同处理一件山子的造型和纹饰，有的时候是用某几种方法对山子进行处理。从写实性上看，山子重峦叠嶂，小桥流水，亭台楼阁，景色壮美，总之还是比较写实，写意的作品，完整者很少见。但在写实作品中间有见写意的部分，不过基本上都被限定在很小的范围之内。总之，蜜蜡山子在做工上相当细腻，大多数作品可谓是巧夺天工，犹如幻境，具有极高的观赏价值。

蜜蜡山子摆件

蜜蜡山子摆件

(5) 从功能上鉴定：当代蜜蜡山子在功能上继承了传统，以摆件为主，也就是陈设观赏的功能更加突出。另外，珍贵器具的功能也更加突出，这是由蜜蜡材质的珍贵性决定的。在室内摆件蜜蜡山子，显然是提高身份地位的标志性物件。还有艺术品的功能也是很强，人们将其作为比陈设观赏更为深层次的艺术品来品味。观赏这些艺术品可以陶冶情操，在喧闹的都市之中寻找山子之中意境的那份宁静，我们在鉴赏之中应注意体会。

总之，蜜蜡山子契合了古代和当代人们的多种需求，其画面意境之深刻，表达之淋漓尽致，层次分明之布局合理性，都令人们所感叹。总之山子是我国蜜蜡雕件的一大创举，当代最为流行。其气势雄伟的造型，装饰繁缛、而富有层次感的纹饰，使得人们如痴如醉，可以说件件都是精品力作，代表着同时期最高的工艺水平。

蜜蜡山子摆件

蜜蜡山子摆件

蜜蜡山子摆件

蜜蜡山子摆件

蜜蜡山子摆件

第四章　识市场

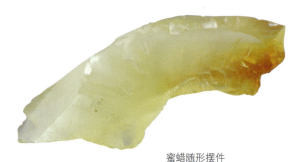

蜜蜡随形摆件

第一节　逛市场

一、国有文物商店

国有文物商店收藏的蜜蜡具有其他艺术品销售实体所不具备的优势，一是实力雄厚；二是古代蜜蜡数量较多；三是中高级专业鉴定人员多；四是在进货渠道上层层把关；五是国有企业集体定价，价格不会太离谱。国有文物商店是我们购买蜜蜡的好去处。基本上每一个省都有国有的文物商店，分布较为均衡。国有文物商店蜜蜡品质优劣见表 4-1。

蜜蜡如意

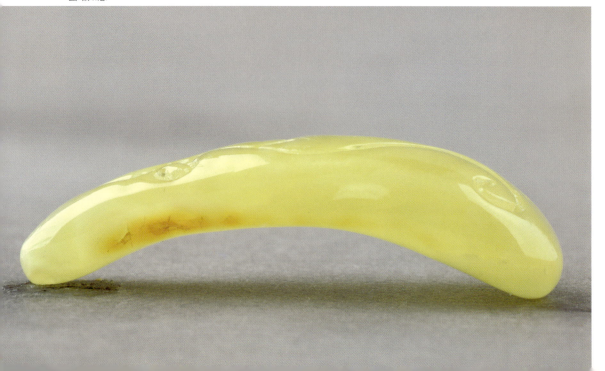

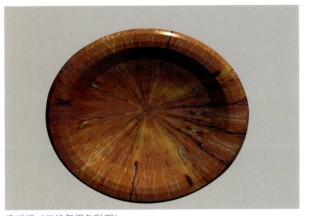
蜜蜡碟（三维复原色彩图）

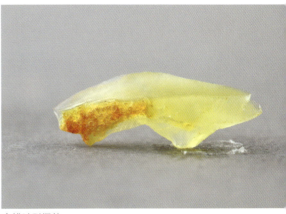
蜜蜡随形摆件

表 4-1 国有文物商店蜜蜡品质优劣表

名称	时代	品种	数量	品质	体积	检测	市场
蜜蜡	高古	极少	极少	优/普	小器为主	通常无	国有文物商店
	明清	稀少	少见	优/普	小器为主	通常无	
	民国	稀少	少见	优/普	小器为主	通常无	
	当代	多	多	优/普	大小兼备	有/无	

由表 4-1 可见，从时代上看，国有文物商店蜜蜡古代有见，但比明清时期早的蜜蜡很少见。而我们知道，蜜蜡在汉唐时期已是相当流行，但这些蜜蜡多是随葬在墓葬当中，很多都保存在博物馆中，而明清时期距离现在时间比较近，而且传世品比较多，所以遗留下来的比较多，在国有的文物商店内较为常见。民国延续明清，当代蜜蜡达到了鼎盛。从品种上看，古代蜜蜡品种并不多，直至民国时期都是这样，而当代蜜蜡在品种上比较齐全，如老蜡、浅黄蜜蜡、鸡油黄蜜蜡、橘红蜜蜡、米色蜜蜡、青色蜜

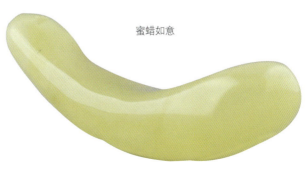
蜜蜡如意

蜜蜡随形摆件

蜜蜡随形摆件

蜡、褐色蜜蜡、米白色蜜蜡、白色蜜蜡、棕色蜜蜡、蛋青色蜜蜡、绿色蜜蜡、土色蜜蜡、咖啡蜜蜡、红棕等诸色蜜蜡都有见。从数量上看，国有文物商店内的高古蜜蜡极为少见，主要是明清民国时期有见，但数量也是比较少，只有当代蜜蜡在数量上比较多见，可以说是应有尽有，这主要得益于当代蜜蜡在原料上的充足性。从品质上看，古代蜜蜡在品质上较为优良但普通者也有见；当代蜜蜡在品质上优质者众多，普通者也有见，但数量很少。从体积上看，国有文物商店内的蜜蜡高古、明清、民国都是以小器为主，这主要是由于蜜蜡在古代原料过于稀缺所导致。当代蜜蜡原料充足，在体积上依然是以小器为多见，但大器有见，基本上形成大小兼备的格局。从检测上看，古代蜜蜡通常没有检测证书，当代蜜蜡有的有检测证书，但只是一些物理性质的数据，优良程度并不能确定。

蜜蜡镯（三维复原色彩图）

老蜡珠、西周和田青玉灯（三维复原色彩图）

蜜蜡随形摆件

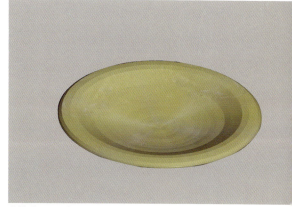
蜜蜡碟（三维复原色彩图）

二、大中型古玩市场

大中型古玩市场是蜜蜡销售的主战场，如北京的琉璃厂、潘家园等，以及郑州古玩城、兰州古玩城、武汉古玩城等都属于比较大的古玩市场，这里集中了很多蜜蜡销售商。像北京的报国寺市场只能算作是中型的古玩市场。大中型古玩市场蜜蜡品质优劣见表 4-2。

蜜蜡随形摆件

表4-2 大中型古玩市场蜜蜡品质优劣表

名称	时代	品种	数量	品质	体积	检测	市场
蜜蜡	高古	极少	极少	优／普	小	通常无	大中型古玩市场
	明清	稀少	少见	优／普	小器为主	通常无	
	民国	稀少	少见	优／普	小器为主	通常无	
	当代	多	多	优／普	大小兼备	有／无	

蜜蜡如意

蜜蜡随形摆件

由表 4-2 可见，从时代上看，大中型古玩市场的蜜蜡时代特征明确。古代、明清、民国和当代都有见，只是古董蜜蜡比较稀少，而当代蜜蜡数量比较多而已。从品种上看，蜜蜡在古代比较单一，主要以棕、褐等色的老蜡为主，当代蜜蜡的种类较多，如浅黄蜜蜡、鸡油黄蜜蜡、橘红蜜蜡、米色蜜蜡等都是比较流行。从数量上看，高古蜜蜡在文物商店内出现数量极少，基本上以明清及民国时期为主，但数量也是比较少。当代大中型古玩市场内的蜜蜡比较多，店铺内琳琅满目，雕件、串珠、山子、佛像等应有尽有，很多都是批发的门店；从品质上看，蜜蜡在品质上无论是古代还是当代基本上都是以优良为主，但是普通者也有见，特别是当代优质料很常见。从体积上看，大中型古玩市场内的蜜蜡古代以小件为主，很少见到大器，而当代的蜜蜡则在体积上是大小兼备，但依然是以小器为多见。从检测上看，古代蜜蜡进行检测的很少见，但是当代蜜蜡基本上都进行过检测，有很多本身带有检测证书。

老蜡珠

不规则仿蜜蜡珠

蜜蜡随形摆件

三、自发形成的古玩市场

自发形成的古玩市场三五户成群，大一点几十户，这类市场不很稳定，有时不停地换地方，但却是我们购买蜜蜡的好去处。自发古玩市场蜜蜡品质优劣见表4-3。

表4-3 自发古玩市场蜜蜡品质优劣表

名称	时代	品种	数量	品质	体积	检测	市场
蜜蜡	高古						自发古玩市场
	明清	稀少	少见	普/劣	小器为主	通常无	
	民国	稀少	少见	普/劣	小器为主	通常无	
	当代	多	多	优/普	大小兼备	通常无	

由表4-3可见，从时代上看，自发形成的古玩市场上的蜜蜡明清时期有见，明清时期之前的不能说没有真货，但真的是如大海捞针一般，以当代蜜蜡为多见。从品种上看，自发形成的古玩市场上的蜜蜡明清和民国时期品种都很少见，以当代最为常见。从数量上看，明清和民国时期的都很少见，主要以当代为多见。从品质上看，明清和民国时期，普通和恶劣的情况都有见，精致者很少见；当代主要以优良料和普通者为主，过于粗制者很少见。从体积上看，明清及民国时期基本以小器为主，当代则是大小兼备，这主要是由于当代大量的蜜蜡被进口到国内，原料较为充足。从检测上看，这类自发形成的小市场上基本没有检测证书，全靠眼力。

第一节 逛市场

蜜蜡随形摆件

蜜蜡随形摆件

蜜蜡随形摆件

四、大型商场

大型商场也是蜜蜡销售的好地方，因为蜜蜡本身就是奢侈品，同大型商场血脉相连。大型商场内的蜜蜡琳琅满目，各种蜜蜡应有尽有，在蜜蜡市场上占据着主要位置。大型商场蜜蜡品质优劣见表4-4。

表 4-4 大型商场蜜蜡品质优劣表

名称	时代	品种	数量	品质	体积	检测	市场
蜜蜡	高古						大型商场
	当代	多	多	优/普	大小兼备	通常无	

蜜蜡串珠

蜜蜡随形摆件

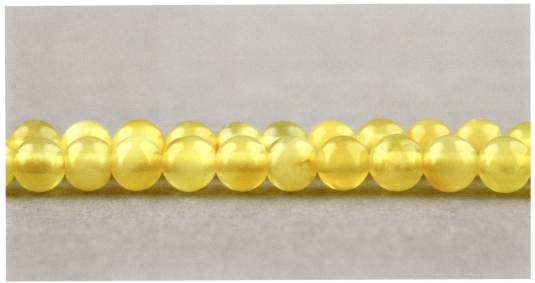
蜜蜡串珠

由表4-4可见，从时代上看，大型商场内的蜜蜡以当代为主，古代基本没有。从品种上看，商场内蜜蜡的种类非常多，老蜡、浅黄蜜蜡、鸡油黄蜜蜡、橘红蜜蜡、米色蜜蜡、青色蜜蜡、褐色蜜蜡、米白色蜜蜡、白色蜜蜡、棕色蜜蜡、蛋青色蜜蜡、绿色蜜蜡、土色蜜蜡、咖啡蜜蜡、红棕等诸色蜜蜡都有见。从数量上看，各类蜜蜡都非常多，可选择性比较大。从品质上看，大型商场内的蜜蜡在品质上以优质为主，普通者有见，但是粗者几乎很少见。从体积上看，大型商场内蜜蜡大小兼备，大到山子、摆件，小到摆件、串珠等都有见，因为从计价方式上看，当代蜜蜡主要是以称重计价，这也是客观上蜜蜡制品体积上升的一个要素。从检测上看，大型商场内的蜜蜡由于比较精致，十分贵重，多数有检测证书。

蜜蜡随形摆件

蜜蜡随形摆件

蜜蜡如意

五、大型展会

大型展会,如蜜蜡订货会、工艺品展会、文博会等成为蜜蜡销售的新市场。大型展会蜜蜡品质优劣见表 4-5。

表 4-5 大型展会蜜蜡品质优劣表

名称	时代	品种	数量	品质	体积	检测	市场
蜜蜡	高古						大型展会
	明清	稀少	少见	优/普	小器为主	通常无	
	民国	稀少	少见	优/普	小器为主	通常无	
	当代	多	多	优/普	大小兼备	通常无	

由表 4-5 可见,从时代上看,大型展会上的蜜蜡明清、民国时期多见,但总量不大,以当代为主。从品种上看,大型展会蜜蜡品种比较多,已知的蜜蜡品质基本上在展会上都能找到。从数量上看,各种蜜蜡琳琅满目,数量很多,各个批发的摊位上可以看到整麻袋的串珠、挂件等。从品质上看,大型展会上的蜜蜡在品质上可谓是优良者有见,更有见普通者,但是低等级的蜜蜡很少见。从体积上看,大型展会上的蜜蜡在体积上大小都有见,体积已不是蜜蜡价格高低的标志,这与当代蜜蜡原石开采的规模化有关,主要以品质为判断标准。从检测上看,大型展会上的蜜蜡多数无检测报告,只有少数有检测报告,但也只能证明是蜜蜡,其优良程度需要自己判断。

蜜蜡随形摆件

仿蜜蜡筒珠

第一节 逛市场 **125**

蜜蜡如意

仿老蜡珠

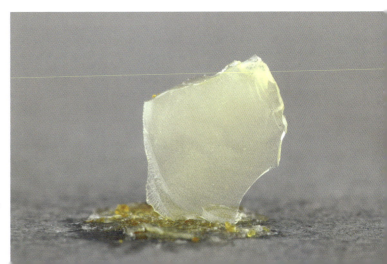

蜜蜡随形摆件

六、网上淘宝

网上购物近些年来成为时尚,同样网上也可以购买蜜蜡,网上搜索会出现许多销售蜜蜡的网站,下面我们来通过表4-6具体看一下。

表4-6 网络市场蜜蜡品质优劣表

名称	时代	品种	数量	品质	体积	检测	市场
蜜蜡	高古	极少	极少	优/普	小	通常无	网络市场
	明清	稀少	少见	优/普/劣	小器为主	通常无	
	民国	稀少	少见	优/普/劣	小器为主	通常无	
	当代	多	多	优/普	大小兼备	有/无	

鸡油黄蜜蜡碗(三维复原色彩图)

仿鸡油黄执壶(三维复原色彩图)

蜜蜡串珠、莫莫珊瑚碟（三维复原色彩图）

　　由表 4-6 可见，从时代上看，网上淘宝可以很便捷地买到各个时代的蜜蜡，随意搜索时代名称加蜜蜡即可。但是，通常情况下明清、民国时期有见，不过数量很少，明清以前的高古蜜蜡几乎不见。从品种上看，蜜蜡的品种极全，几乎囊括所有的蜜蜡品类，如老蜡、浅黄蜜蜡、鸡油黄蜜蜡、橘红蜜蜡、米色蜜蜡、青色蜜蜡、褐色蜜蜡、米白色蜜蜡、白色蜜蜡、棕色蜜蜡、绿色蜜蜡、土色蜜蜡等。从数量上看，各种蜜蜡的数量也是应有尽有，只不过相对来讲黄色蜜蜡最多。从品质上看，蜜蜡的品质高古以优良和普通为主；明清、民国时期则是优良、普通、粗劣者都有见；当代则是以优良和普通为多见，粗劣者几乎不见。这说明当代蜜蜡在质量上有了飞跃。从体积上看，古代蜜蜡绝对是小器，高古器皿都很小；明清、民国时期体积有所增大，但依然是以小器为主；当代蜜蜡在体积上有很大进步，大小兼备格局业已形成。从检测上看，网上淘宝而来的蜜蜡大多没有检测证书，只有一少部分有见检测证书，初级藏家建议以买有检测证书者为宜。但证书只是其物理性质的描述，并不能对品质进行有效的判断，这一点我们在购买时应注意分辨。

蜜蜡随形摆件

蜜蜡随形摆件

七、拍卖行

蜜蜡拍卖是拍卖行传统的业务之一,是我们淘宝的好地方,具体我们来看下表 4-7。

表 4-7 拍卖行蜜蜡品质优劣表

名称	时代	品种	数量	品质	体积	检测	市场
蜜蜡	高古	极少	极少	优/普	小	通常无	拍卖行
	明清	稀少	少见	优良	小器为主	通常无	
	民国	稀少	少见	优良	小器为主	通常无	
	当代	多	多	优/普	大小兼备	通常无	

老蜡珠

蜜蜡随形摆件

蜜蜡摆件

蜜蜡随形摆件

由表4-7可见，从时代上看，拍卖行拍卖的蜜蜡各个历史时期的都有见，但高古蜜蜡多是偶见，主要以明清和民国及当代蜜蜡为主。从品种上看，拍卖市场上的蜜蜡在品种上比较齐全，以各种彩色蜜蜡为显著特征。黄色的蜜蜡其实并不是主角，只是因为其价格相对便宜，所以数量比较多而已。从数量上看，古代蜜蜡罕见有拍卖；而明清、民国时期已经是比较多见；但是相对于当代还是属于绝对的少数。从品质上看，高古蜜蜡优良和普通的质地都有见；而明清、民国时期的蜜蜡主要是以优良品质为主；当代蜜蜡在拍卖场上则是优良和普通者都有见。从体积上看，古代蜜蜡在拍卖行出现也是无大器；明清、民国几乎延续了这一特点，只是偶见大器；当代蜜蜡在体积大小上则是有很大进步，大小兼备。从检测上看，拍卖场上的蜜蜡一般情况下也没有检测证书，特别是古代蜜蜡更是这样，当代蜜蜡有的有检测证书。

蜜蜡串珠

蜜蜡执壶（三维复原色彩图）

八、典当行

典当行也是购买蜜蜡的好去处,典当行的特点是对来货把关比较严格,一般都是死当的蜜蜡作品才会被用来销售。具体我们来看表 4-8。

表 4-8 拍卖行蜜蜡品质优劣表

名称	时代	品种	数量	品质	体积	检测	市场
蜜蜡	高古	极少	极少	优/普	小	通常无	典当行
	明清	稀少	少见	优良	小器为主	通常无	
	民国	稀少	少见	优良	小器为主	通常无	
	当代	多	多	优/普	大小兼备	有/无	

蜜蜡串珠

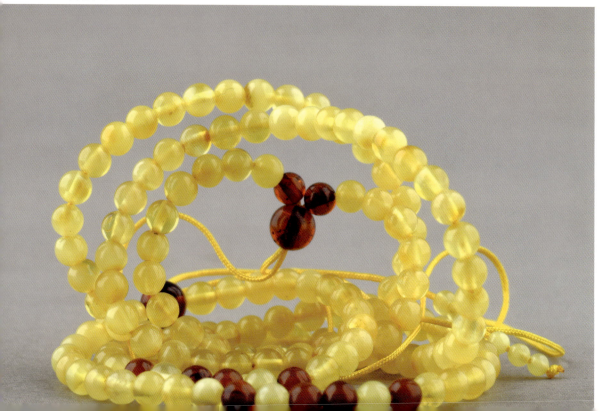

蜜蜡随形摆件

蜜蜡随形摆件

 由表 4-8 可见，从时代上看，典当行的蜜蜡古代和当代都有见，明清和民国时期的制品虽然不是很多，但也是时常有见，主要以当代为多见。从品种上看，典当行蜜蜡的品质古代以黄色为多见，棕红色等也多见，但总之是种类有限；明清时期在品种上已是比较常见，但相对于当代还是稀少的；当代蜜蜡品种极为丰富，几乎涉及浅黄、鸡油黄、橘红、米色、青色、褐色、米白色、白色、棕色、蛋青色、绿色、土色、咖啡、红棕等诸色蜜蜡。从数量上看，高古蜜蜡的数量极少，明清和民国时期蜜蜡也是比较少见，只有当代蜜蜡在典当行是比较常见，是销售的主流。从品质上看，典当行内的蜜蜡古代以优质和普通者为常见，当代由于数量比较大，所以在蜜蜡品质上多数是精品，但也有部分普通品，品质差者几乎不见。这与当代蜜蜡原料整体优良程度的提高有关。从体积上看，古代蜜蜡的体积一般都比较小，很少见到大器，典当行内的蜜蜡主要以小器为主，大器偶见；当代蜜蜡已是大小兼备。从检测上看，典当行内的蜜蜡制品无论古代和当代真正有检测证书的几乎不见，当代的蜜蜡多数有检测证书，但一般都是死当时的检测证书。

第二节 评价格

一、市场参考价

蜜蜡具有很高的保值和升值功能,不过蜜蜡的价格与时代以及工艺的关系密切。蜜蜡虽然在古代就有见,但是普及的时间主要是在明清以后,特别是当代异常流行,人们对其趋之若鹜,在整个蜜蜡史当中形成了明清和当代在价格上对峙的局面。其特点是,明清时期和当代都有价值百万以上者,同时也有几百上千价位较低者。这向人们昭示了一个道理,古今蜜蜡以品质为上,一般人们以能够收藏到高品质的蜜蜡为荣,而普通品质蜜蜡则多是入门级,真正高品质蜜蜡价格可谓是一路所向披靡,青云直上九重天,具有很高的升值潜力。由此可见,蜜蜡的参考价格也比较复杂。下面,让我们来看一下蜜蜡主要的价格。但是,这个价格只是一个参考,因为本书价格是已经抽象过的价格,是研究用的价格,实际上已经隐去了该行业的商业机密,如有雷同,纯属巧合,仅仅是给读者一个参考而已。

蜜蜡随形摆件

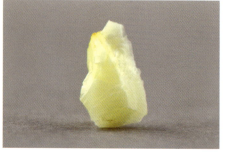

蜜蜡随形摆件

蜜蜡随形摆件

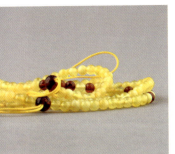
蜜蜡串珠

蜜蜡执壶（三维复原色彩图）

蜜蜡随形摆件

明 蜜蜡洗：42万～48万元
清 乾隆朝珠：83万～220万元
清 蜜蜡配青金项链：0.6万～0.8万元
清 老蜜蜡多宝项链：0.6万～1.6万元
清 老蜜蜡配青金石项链：0.4万～0.8万元
清 蜜蜡配玛瑙项链：0.2万～0.3万元
清 蜜蜡手串：0.9万～1.3万元
清 蜜蜡佛手：0.9万～1.6万元
清 蜜蜡随形山子：1万～2万元
清 蜜蜡牌：0.6万～0.9万元
清 蜜蜡坠：0.9万～1.3万元
清 蜜蜡朝珠：3.6万～5万元
清 蜜蜡觽：0.28万～0.4万元
清 蜜蜡项链：0.5万～0.8万元
清 蜜蜡烟壶：2.2万～3.3万元
清 蜜蜡墨床：0.6万～0.9万元
当代 高品质蜜蜡原石：88万～160万元
当代 高品质蜜蜡手串：163万～343万元
当代 蜜蜡摆件：0.9万～1.3万元
当代 蜜蜡随形山子：0.7万～0.9万元
当代 蜜蜡项链：0.2万～3万元
当代 蜜蜡手镯：3万～4万元
当代 波罗的海蜜蜡手串：0.5万～0.6万元
当代 蜜蜡、血珀手串：0.4万～0.7万元
当代 蜜蜡、金刚菩提手串：0.4万～0.6万元
当代 蜜蜡、血珀手串：0.9万～1.8万元
当代 缅甸蜜蜡手串：2万～3万元
当代 蜜蜡、菩提手串：0.9万～1.2万元

当代 蜜蜡、椰壳手串：0.9万～2.8万元
当代 蜜蜡多宝串：3万～3.8万元
当代 鸡油黄蜜蜡手串：3万～7.6万元
当代 蜜蜡、绿松石顶珠挂饰：0.48万～0.5万元
当代 蜜蜡、珊瑚隔珠挂饰：0.6万～0.8万元
当代 蜜蜡、绿松石隔珠挂饰：2万～28万元
当代 蜜蜡、绿松石隔珠项链：2万～3万元
当代 蜜蜡、珊瑚隔珠项链：0.7万～1.3万元
当代 蜜蜡、绿松石隔珠项链：0.9万～1.5万元
当代 蜜蜡、血珀项链挂饰：3万～3.6万元
当代 蜜蜡三颗、绿松石隔珠项链：0.4万～0.5万元
当代 蜜蜡三颗、珊瑚隔珠项链：2万～3万元
当代 蜜蜡挂坠：0.6万～4万元
当代 蜜蜡、松石隔珠挂坠：3万～5万元
当代 蜜蜡、砗磲顶珠挂饰：2万～2.8万元
当代 蜜蜡108颗念珠：9万～18万元
当代 蜜蜡珠链：6万～9万元
当代 蜜蜡手串：3万～19万元
当代 蜜蜡、琉璃珠挂饰：3万～6万元
当代 蜜蜡挂饰：2万～5万元
当代 蜜蜡、血珀、绿松石项链：3.5万～5.5万元
当代 蜜蜡、松石挂饰：4.3万～6.6万元
当代 蜜蜡组合项链：6.8万～9.8万元
当代 蜜蜡、琉璃项链：1.8万～3.2万元
当代 蜜蜡组合项链：3.8万～5.2万元
当代 蜜蜡、琉璃珠坠：2.8万～4.2万元
当代 蜜蜡组合项链：1.6万～3.8万元

二、砍价技巧

砍价是一种技巧,但并不是根本性的商业活动,它的目的就是与对方讨价还价,找到对自己最有利的因素。但从根本上讲砍价只是一种技巧,理论上只能将虚高的价格谈下来,但当接近成本时显然是无法真正砍价的。所以忽略蜜蜡的时代及工艺水平来砍价,结果可能不会太理想。通常蜜蜡的砍价主要有这样几个方面:一是品相,老蜜蜡在经历了岁月长河之后大多数已经残缺不全,但一些好的蜜蜡今日依然是可以完整保存,正如我们在博物馆看到的老蜜蜡一样。但从实践中我们也可以看到一些蜜蜡残缺严重,这自然会影响到其价格。找到这样的瑕疵,自然可以成为砍价的利器。二是品质,不同的蜜蜡品质不同,蜜蜡虽然是从琥珀当中分化出来的一个

蜜蜡镯(三维复原色彩图)

蜜蜡随形摆件

蜜蜡随形摆件

品种,但其自身依然可以分化出诸多的品类,如鸡油黄、金黄、白蜡等。不同的蜜蜡品质不同,即使同一种蜜蜡在品质上也多有不同。因为几乎每一块蜜蜡原石在密度、净度,以及色彩等方面都是不同的。优者价值连城,而品质不高者则是价格平平。所以找到品质上的缺陷是对蜜蜡抡锤砸价的关键。三是时代,蜜蜡的时代特征对于蜜蜡的价格影响是巨大的。老蜡不仅具有材质上的价值,而且具有文物价值,其价值往往不可估量。随着对其研究的深入而增加,通常情况下老蜡的价格会远高于新开采出来的蜜蜡。因此时代特征也是砍价的利器。总之,蜜蜡的砍价技巧涉及时代、做工、品质、种类、体积、重量、净度等诸多方面,从中找出缺陷,必将成为砍价利器。

蜜蜡串珠

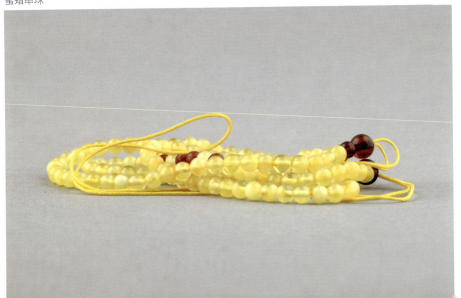

第三节　懂保养

一、清 洗

清洗是收藏到蜜蜡之后很多人要进行的一项工作，目的就是要把蜜蜡表面及其断裂面的灰土和污垢清除干净。在清洗的过程当中首先要保护蜜蜡不受到伤害，一般不采用直接放入自来水中进行清洗，因为水中的多种有害物质会使蜜蜡表面受到伤害，通常是用纯净水或者中性清洁剂来清洗。一般用温水进行，如果有土蚀等，要待到土蚀完全溶解后，再用棉球将其擦拭干净，遇到顽渍可以用牛角刀进行试探性的剔除。如果还未洗净，请送交专业修复机构进行处理，千万不要强行剔除，以免划伤蜜蜡，一般情况下，用手揉搓一下就可以了。

蜜蜡随形摆件

蜜蜡碟（三维复原色彩图）

蜜蜡随形摆件

二、修 复

老蜡有些需要修复,特别是时代久远的古代蜜蜡历经沧桑风雨,大多数需要修复。修复主要包括拼接和配补两部分。拼接就是用黏合剂把破碎的蜜蜡片重新黏合起来,拼接工作比较简单,主要是根据碎块的形状、纹饰等特点,逐块进行拼对,最后拼接完成。配补只有在特别需要的情况下才进行,一般情况下拼接完成就已经完成了考古修复,只有商业修复才将蜜蜡配补到原来的形状。但需标明是修复件。当代蜜蜡制品一般不存在修复的情况。

三、防止高温

蜜蜡与琥珀相似,都怕阳光直射,因此不要将蜜蜡放在太阳光下长时间的暴晒,同时也不要放在有明火的地方,这样会使其颜色有所变化,甚至会产生裂纹等不必要的损失。

四、防止磕碰

蜜蜡由于硬度和密度都不高,所以很容易受到伤害。一般情况下蜜蜡在保存时需要单独放置,或者是独立包装,特别是禁忌同铜、铁、金、银等器物放置在一起,防止磕碰。

蜜蜡随形摆件

蜜蜡随形摆件

蜜蜡随形摆件

五、日常维护

蜜蜡日常维护的第一步是进行测量，对蜜蜡的长度、高度、厚度等有效数据进行测量。目的很明确，就是对蜜蜡进行研究，以及防止被盗或是被调换。第二步是进行拍照，如正视图、俯视图和侧视图等，给蜜蜡保留一个完整的影像资料。第三步是建卡，蜜蜡收藏当中很多机构，如博物馆等，通常给蜜蜡建立卡片。登记内容如名称，包括原来的名字和现在的名字，以及规范的名称；其次是年代，就是这件蜜蜡的制造年代、考古学年代；还有质地、功能、工艺技法、形态特征等的详细文字描述，这样我们就完成了对古蜜蜡收藏最基本的工作。第四步是建账，机构收藏的蜜蜡，如博物馆通常在测量、拍照、卡片、包括绘图等完成以后，还需要入国家财产总登记账和分类账两种，一式一份，不能复制，主要内容是将文物编号，有总登记号、名称、年代、质地、数量、尺寸、级别、完残程度，以及入藏日期等。总登记账要求有电子和纸质两种，是文物的基本账册。藏品分类账也是由总登记号、分类号、名称、年代、质地等组成，

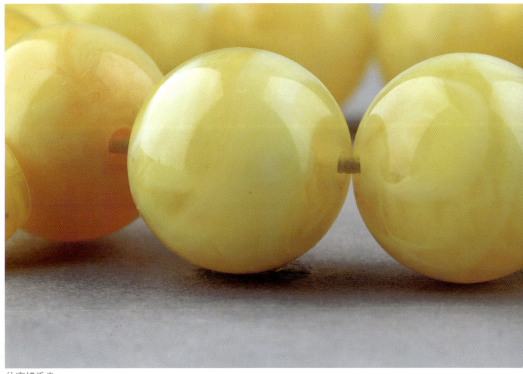

仿蜜蜡手串

以备查阅。第五步是防止磕碰,保存起来,禁止将强酸、强碱滴到蜜蜡上,这样蜜蜡会受到严重伤害。另外,要防止与酒精接触,如指甲油、香水、发胶等,因为这些里面可能会含有酒精。因此,在梳妆打扮时需要将蜜蜡暂时取下来,在洗澡时最好也不要带蜜蜡。

六、相对温度

蜜蜡的保养,室内温度也很重要,特别是对于经过修复复原的蜜蜡,温度尤为重要。因为一般情况下黏合剂都有其温度的最适界限,如果超出就很容易出现黏合不紧密的现象,一般库房温度应保持在20～25摄氏度,这个温度较为适宜,如果温差太大,且来回波动,对于蜜蜡而言也是不利的。

七、相对湿度

蜜蜡在相对湿度上一般应保持在50%左右。如果相对湿度过大,对保存蜜蜡不利;同时也不易过于干燥。保管时还应注意根据蜜蜡的具体情况来适度调整相对湿度。

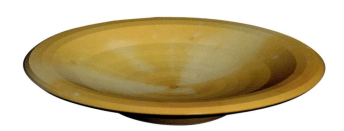

老蜡碟（三维复原色彩图）

第四节　市场趋势

一、价值判断

　　价值判断就是评价值，我们之前所做的很多的工作，就是要做到能够评判价值。在评判价值的过程中，也许一件蜜蜡有很多的价值，但一般来讲我们要能够判断蜜蜡的三大价值，即研究价值、艺术价值、经济价值。当然，这三大价值是建立在诸多鉴定要点的基础之上的。研究价值主要是指在科研上的价值，如透过中国古代蜜蜡之上所蕴含的丰富信息，可以使我们看到不同时代人们的所思所想，复原古代人们生活的点点滴滴，具有很高的历史研究价值等，这些都是研究价值的具体体现。总之，蜜蜡在历史上精品力作众多，对于历史学、人类学、博物馆学、民族学、文物学等诸多领域都有着重要的研究价值，日益成为人们关注的焦点。蜜蜡的艺术价值更为丰富，无论是古代还是当代的蜜蜡在造型艺术、纹饰艺术、书法艺术、色彩艺

蜜蜡如意

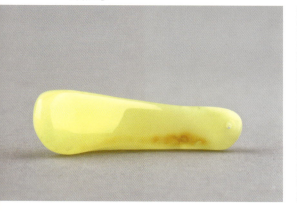

蜜蜡如意

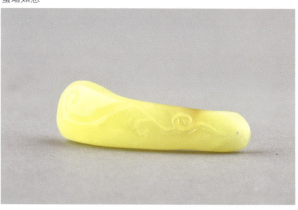

术等方面,都是该时代艺术水平和思想观念的体现,具有较高的艺术价值,而我们收藏的目的之一就是要挖掘这些艺术价值。另外,蜜蜡具有很高的经济价值,其研究价值、艺术价值、经济价值互为支撑,相辅相成,呈现出的是正比的关系。研究价值和艺术价值越高,经济价值就会越高,反之,经济价值则逐渐降低。蜜蜡还受到稀缺、色彩、做工、残缺等诸多要素的影响。

蜜蜡串珠

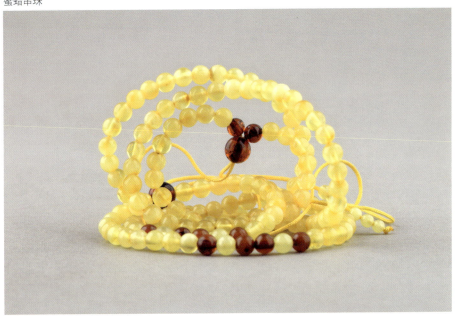

蜜蜡如意、绞胎盘(三维复原色彩图)

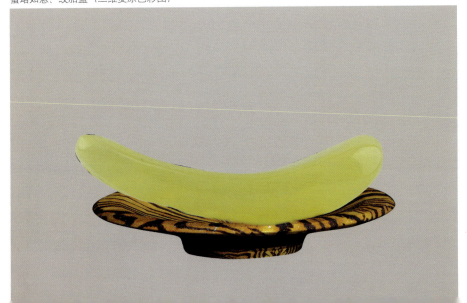

蜜蜡随形摆件

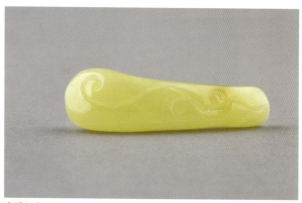
蜜蜡如意

二、保值与升值

古代蜜蜡在中国有着悠久的历史，蜜蜡在古代就常见，但在古代比当代更为稀少，更为贵重。因为我国的蜜蜡资源并不是很丰富，主要依靠进口。历史上，每个不同的历史时期流行的蜜蜡种类都有所不同。如当代以鸡油黄等为最多。从蜜蜡收藏的历史来看，它是一种盛世的收藏品，在战争和动荡的年代，人们对于蜜蜡的追求夙愿会降低，而盛世，人们对蜜蜡的情结通常水涨船高，蜜蜡会受到人们追捧，趋之若鹜。特别是净度、密度、色彩俱佳的蜜蜡更是这样。近些年来股市低迷、楼市不稳有所加剧，越来越多的人把目光投向了收藏市场。在这种背景之下，蜜蜡与资本结缘，成为资本追逐的对象，高品质蜜蜡的价格扶摇直上，升值数十上百倍，而且这一趋势依然在迅猛发展。

蜜蜡串珠

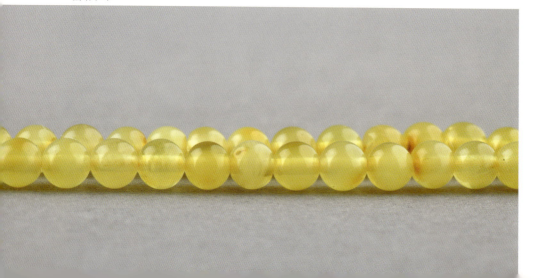

从品质上看,蜜蜡对品质的追求是永恒的。蜜蜡并非都是精品力作,不同品质的蜜蜡价格可谓是有天壤之别,差之毫厘谬之千里。因此,品质对于蜜蜡而言至关重要。显然只有高品质的蜜蜡,才具有很强的保值和升值功能。

从数量上看,对于蜜蜡而言已是不可再生,特别是高品质的蜜蜡数量很少,同样古代蜜蜡的数量也是非常少见,"物以稀为贵",具有很强的保值、升值功能。

总之,蜜蜡的消费特别大,人们对蜜蜡趋之若鹜,蜜蜡不断爆出天价,被各个国家收藏者所收藏,且又不可再生,所以矛盾也越发严重,蜜蜡保值、升值的功能则会进一步增强。

蜜蜡随形摆件

参考文献

[1] 苏州博物馆. 苏州盘门清代墓葬发掘简报 [J]. 东南文化, 2003(9).
[2] 姚江波. 五招鉴定颜色釉瓷 [M]. 上海:上海科学技术文献出版社, 2010.

**HANGJIA
DAINIXUAN** 行家带你选